15 . 12 . 13

Twelfth Night Mary McCartney

Foreword by Mark Rylance

HENI Publishing

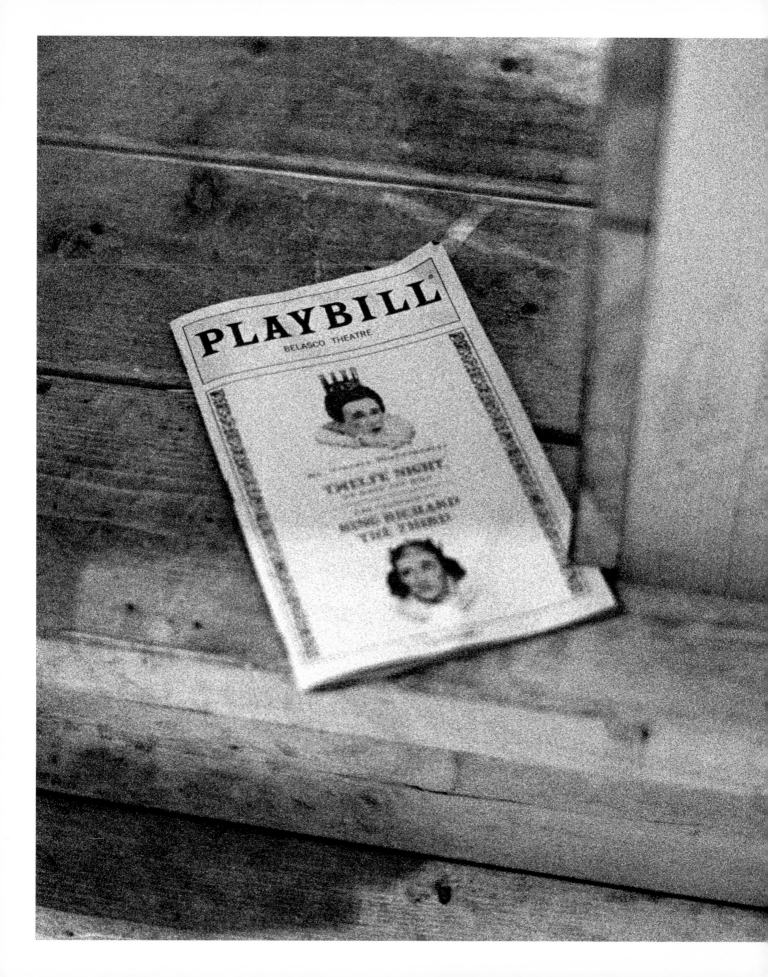

Twelfth Night

Foreword by Mark Rylance 7
Pre-Show 11
First Half 45
Intermission 69
Second Half 89
Post-Show 109
Closer to the Magic by Farah Karim Cooper 123
Acknowledgements 127

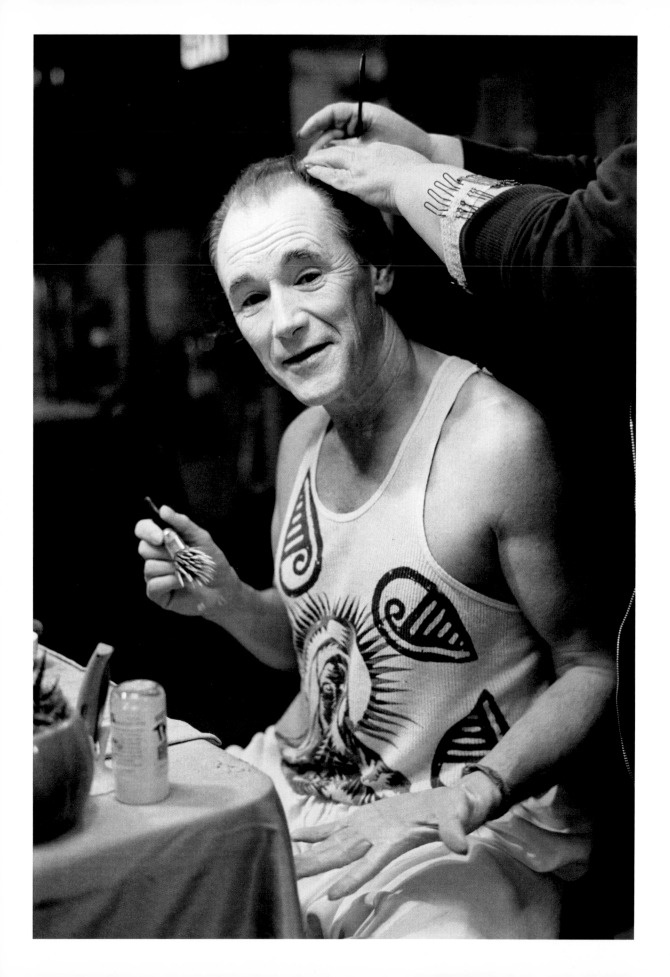

Foreword by Mark Rylance

I have spent thousands of evenings and afternoons backstage in theatres. My earliest memory of a backstage space is a bunch of us crouched behind an overturned table in a school library, where I had created a play about something or other, *The Wizard of Oz*, I think. I must have been about eight years old. The invisible but ever so tangible line between backstage and onstage can be terrifying to cross, especially when you have to immediately say something like "To be or not to be..." or "Now is the winter of our discontent...". It is the nearest I come in this life, I sometimes imagine, to being born and dying. I have always been fascinated by the sensation.

To be backstage during a play, is to be in a twofold world of secrecy and revelation, truth and deception. It is to live in two times at once, the time of your own life and the time of the character you play. There is a similar feeling standing next to a river, a bonfire, on a platform when a fast train is approaching, or, I imagine, beside an open door on an aeroplane. Perhaps, in fact, most likely, I am being dramatic in my choice of imagery, but there is an aspect of psychological life and death, at least, in the whole experience.

Backstage, during a play, I always have one ear to the house, judging the energy of the audience from their response to other scenes, enjoying the innovations and discoveries of my fellow actors as they play, and privately harnessing the aspects of myself, the desires, thoughts and actions, that are appropriate for my character in the play. In this case I was playing the Countess Olivia, a grieving aristocrat who had inherited control of her house and its difficult occupants after the death of both her beloved father and brother.

It is rare to invite a photographer backstage and difficult for a photographer to capture such a dimly lit secret world, but I have often wanted to share the beautiful images I have witnessed backstage, so when Mary asked to photograph my preparation for the role of Olivia in Shakespeare's *Twelfth Night*, I asked the company if she might remain during the performance and they kindly agreed. So, much to her surprise, she found herself backstage during our play. I enjoy the anachronistic marriage of old and new that Mary has photographed, the beauty of our Shakespearean clothes next to our modern clothes, but most of all, I treasure the photographs of actors waiting to cross that invisible line between backstage and onstage. I don't know of a photographer being present at these moments before. To be able to spontaneously photograph this world without any preparation is credit to Mary's skill.

Just as there is a certain ritual, a pattern, to the action onstage, so too, backstage. The quiet preparation for an entrance, quick costume change, motivated exit that deflates rapidly in the dark, the self critical dip of the head, the jubilant energy with an expressive audience, the relaxed energy of players finishing their role and waiting for the final call, the regular absence from the stage, which allows reading, correspondence or better, games of backgammon, ping pong; all the after and before life of actors backstage shadows exactly the life onstage. It is governed by the life onstage. It is both a private and a social space.

You share in the joy and grief of your fellows. It is at its best during an ensemble play such as *Twelfth Night*. Every company is an ensemble of course, but some plays are not as evenly shared between as many players as *Twelfth Night*. And, in this production the ensemble was enriched because many of us had played together regularly over a number of years, in this production and others, when Mary quietly captured these images one winter's day in New York City.

The Belasco is an old Broadway House, with a large stage. We had room in the wings for two oak *standings*, an old Elizabethan term for raised platforms on which an audience could stand or sit. All of our entrances were via two doors in a reconstructed oak hall screen, which also provided a high gallery for our early musicians. Our screen was modelled on a screen like the one in the Middle Temple Hall in London, where the first recorded performance of the play took place in 1602. In fact, our production began its life in the Middle Temple Hall at Candlemass, on February 2nd, 2002 to mark the 400th anniversary of that original performance, and we had done everything possible to recreate the style and staging of the original performance.

That effort included Claire van Kampen's arrangement of early music and the expert playing of seven early musicians, so backstage, I also had the delight of listening to exquisite live early music. Usually our musicians played on their balcony above the stage, but occasionally, for a different acoustic affect, they would come and play amongst us and then, as you will see, there was the added pleasure of watching them play.

But we didn't choose The Belasco for its size, nor its wonderful staff and crew, front of house and backstage, no, we chose it for the great space underneath the stage where those who wished could dress together and where we could have a ping pong table and post-show social club, sometimes employed during show as well. I had heard that Houdini created the deep sub stage space to enable an elephant to disappear by dropping it through a trapdoor into a tank of water. My friends at The Belasco denied this but there was certainly room for an elephant. It was so cold outside that winter, we spent many a memorable late evening, after the play had finished, playing ping pong, table football and entertaining guests in our Houdini cave. Stephen Fry even donned his Santa Claus suit and passed out gifts for our Christmas party.

The Christmas tree you will see was a present from our wardrobe staff, and you will see the extraordinary care and focus of my wonderful dresser, Jim, as we prepare Olivia together. I became an actor initially for the enjoyable community. I like a family feeling in a theatre company and all the crew, wardrobe, wigs, stage door keepers, the actors and musicians are treated as fellows and friends. This extends to the staff front of house, in the box office and auditorium; cleaners too, if one happens to be in early.

A good theatre, like The Belasco, feels like a great ship. Front of house, its stalls, circle and balcony, are like three great sails filled each day with the imaginative life of an audience. Backstage feels like life below decks. Enjoying a fair run of full houses for a popular comedic play,

as we did with *Twelfth Night*... well, there's nothing like it in all the different acting jobs I have been lucky enough to experience, perhaps in life. It is like sailing a fast ship on a sunny windy day.

This production of *Twelfth Night* is a production directed by Tim Carroll, exploring the original playing practices of Shakespeare's time. We call this work *Original Practices*, or, *OP productions*, inspired by Sam Wanamaker's approach to rebuilding the Globe Theatre in London. In an OP production we explore as many of the known original playing practices of Shakespeare's day as we can and try not to do anything they couldn't have done. Hence we are an all male company of actors and three of us play the female roles. We use authentic make up materials, including silk wigs. We play in a shared candlelight on an authentic wooden stage, with no scenery, minimal props and furniture. As I have said, live acoustic music of the period is played on authentic early instruments. A dance called a *jig*, created by Sian Williams, ends the play, and we wear fabulous clothing, carefully researched and reconstructed, usually by hand, by our designer Jenny Tiramani and her School of Historical Dress. We also, out of necessity, use many modern tools of theatre, but we try to hide them. You will see steel deck platforms behind the oak set and we used electric lights to supplement the candlelight in The Belasco but we kept the lights on all the time, never altering the lights to aid the story. We also light the audience so that we can speak with them face-to-face as happened in Shakespeare's day.

These four artists, Tim, Jenny, Claire, Sian, and a large proportion of the acting company, had developed OP productions over the course of my time as Artistic Director of Shakespeare's Globe Theatre, 1996–2005. We felt we were honoring Sam Wanamaker's vision of rebuilding a true Globe Theatre based on careful research, original craft and authentic materials. Over the years, we must have played *Twelfth Night* at least 300 times in different formations, almost like a ballet company, with players leaving and returning, moving to different parts, as did Sam Barnett playing both twins, Sebastian and then Viola. Some have grown too old to play their part, such as our first and second Viola, Eddie Redmayne and Michael Brown. Some have passed, bless them, such as Bill Stewart and Peter Shorey, who played Toby Belch and Maria for many years. Some were joining for the first time in NYC, such as Stephen Fry. It was for me the most mature, humorous and accomplished ensemble of artists I have ever worked with, infected by a joyous play and good friendship. I trust we will make a few more productions before we are done!

This work was originally commissioned in 2001 by the Middle Temple Hall and produced by Shakespeare's Globe Theatre for the 2002 Season of Cupid and Psyche. 2Luck Concepts toured it across America in 2003. In 2012 Shakespeare's Globe revived the production with a production of *Richard III* and Sonia Friedman Productions transferred both productions to the Apollo Theatre in London's West End and The Belasco Theatre on Broadway. A Thousand and One Nights encouraged us to imagine such a revival from 2005.

I hope you will enjoy this rare peep backstage that Mary has so spontaneously and sensitively photographed.

Pre-Show

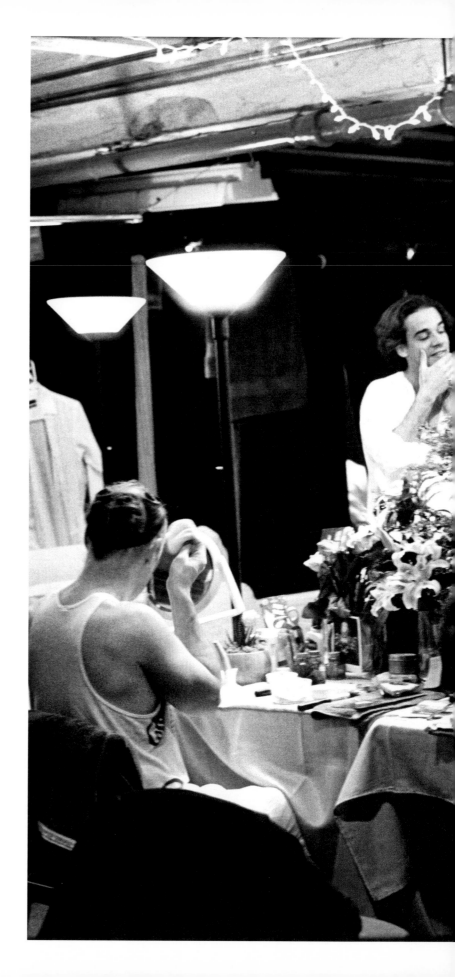

"I'd be happy just doing theatre. I finally clarified why I was doing what I was doing. It wasn't for money, it wasn't for fame—it was to be good at something, something I did that people thought I was good at but really, the deep need that I had was community." — Mark Rylance

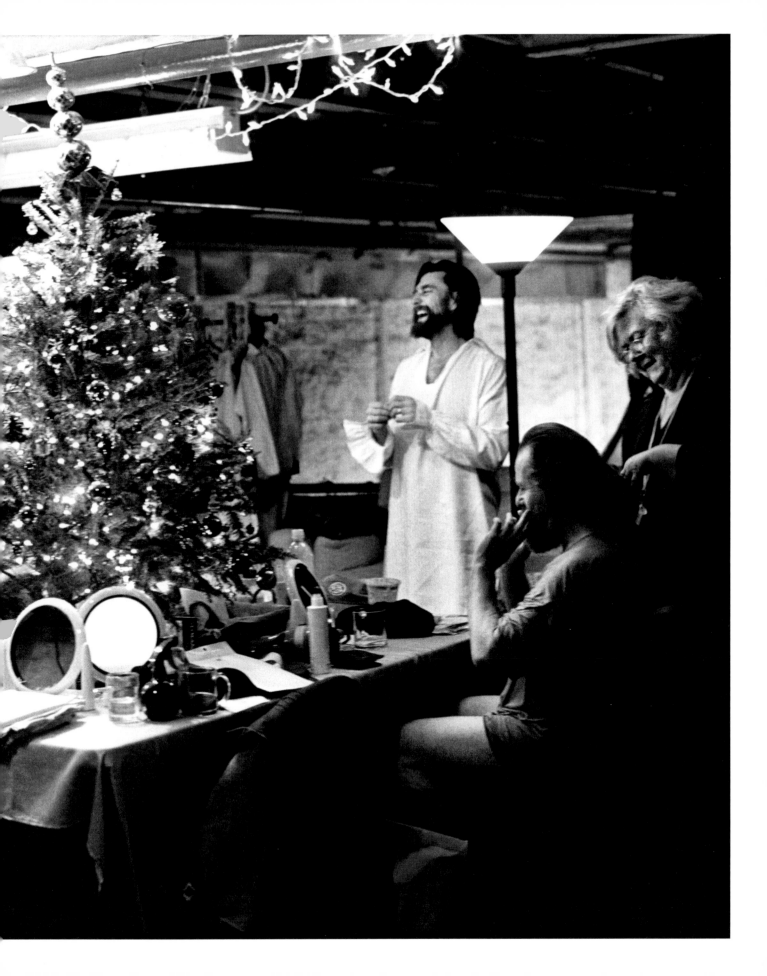

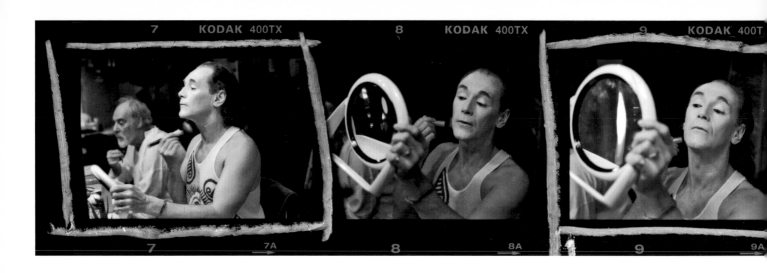

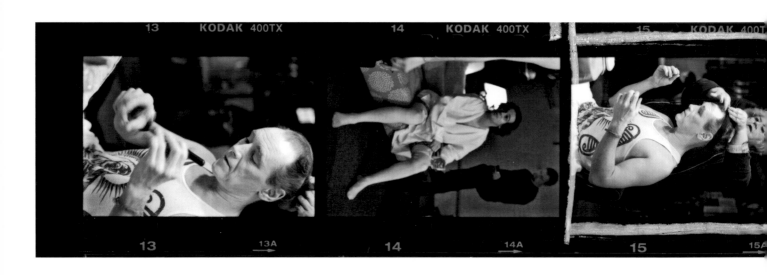

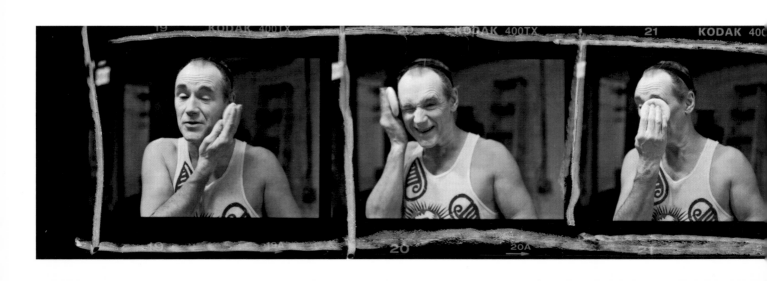

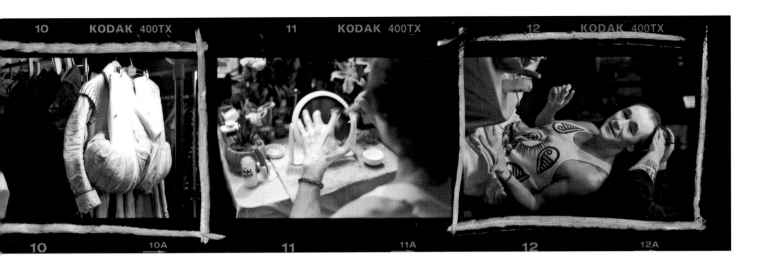

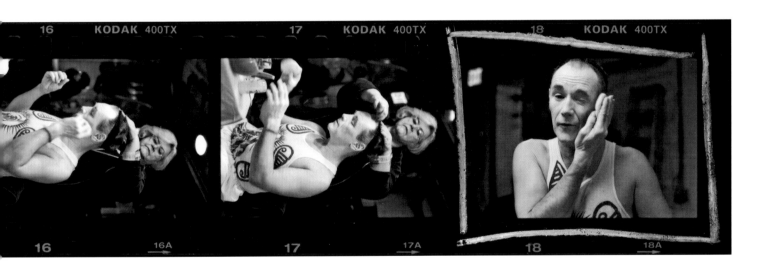

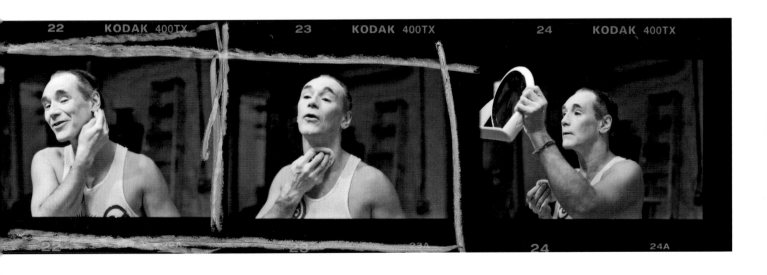

"I thought with [my character] Olivia, she's an expression of the change from winter to spring, in that she's very engrossed in grief and is still. By the end of the play, she has a huge spear and is acting crazy, she's like spring, when all the water melts and all the ice flows." — **Mark Rylance**

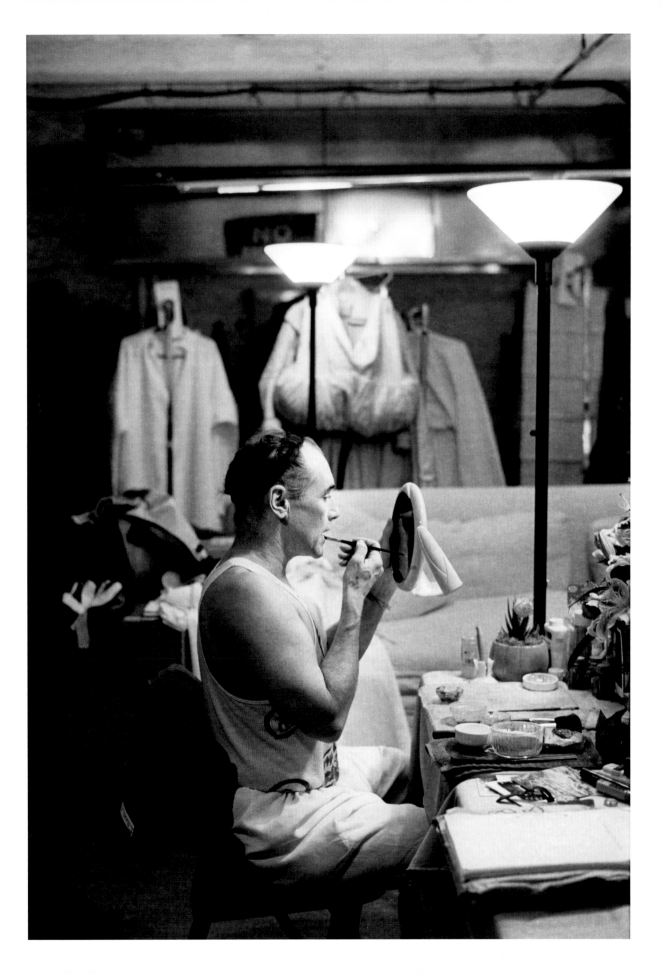

"I played this part from 2002 to 12 years later.
I was only 42 and here I'm 54. Time has brought
me on a bit. You know, when I saw the Kabuki,
it inspired me. They're playing young characters
at 60 and older. The Kabuki theatre culture admires
the artistry involved, as well as the artistry of a very
old person playing a young person. I like that.
There's an innocence that comes to elderly people,
not that I'm quite at that age, but there's an innocence.
It's very good for young characters." — Mark Rylance

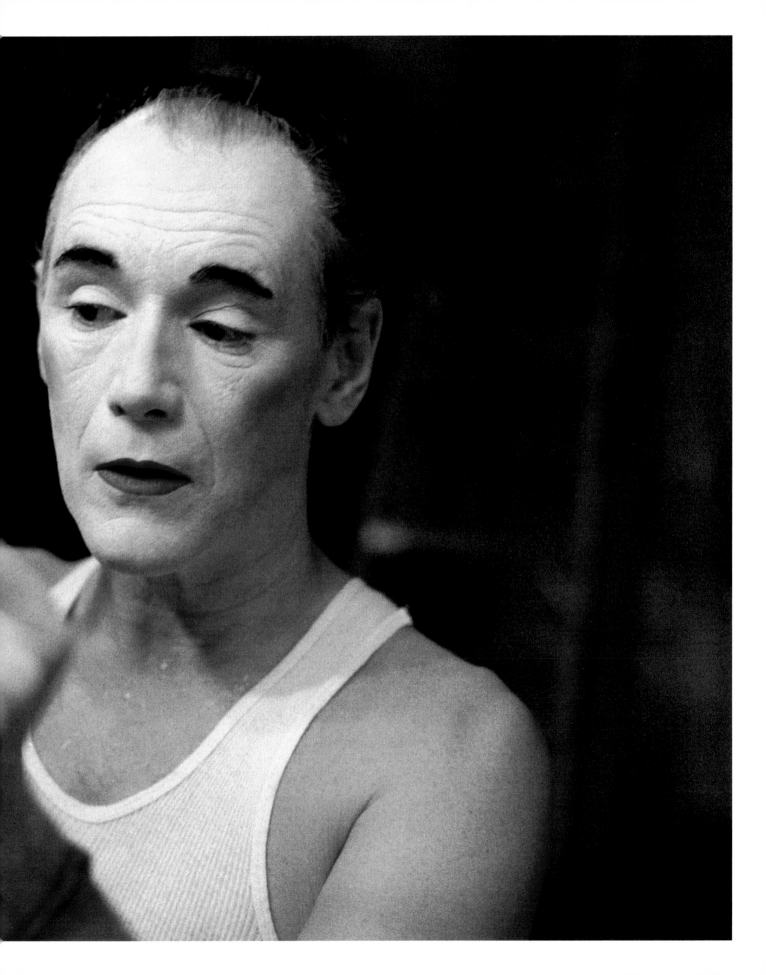

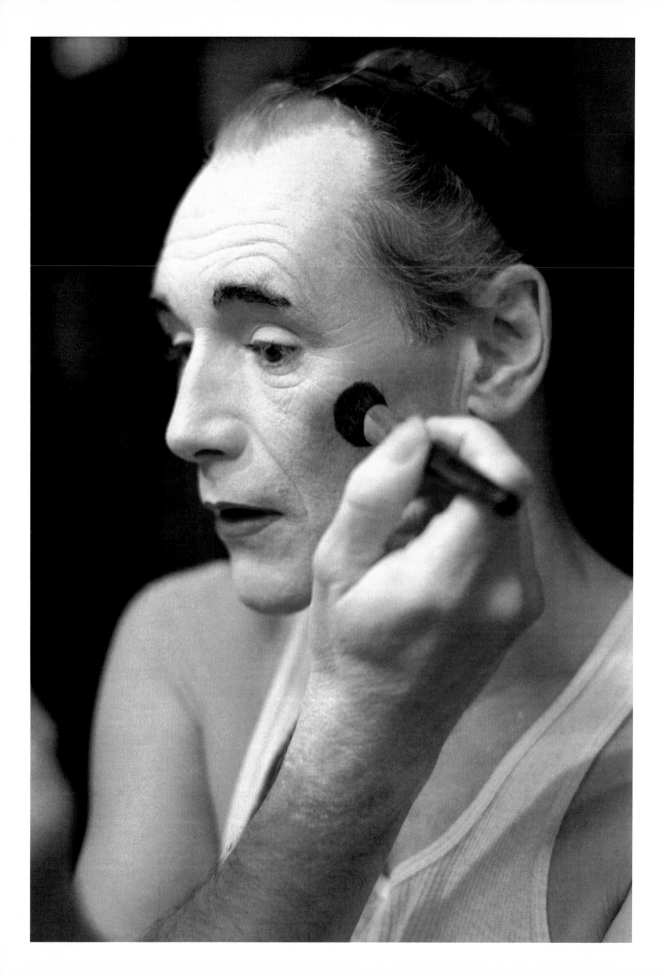

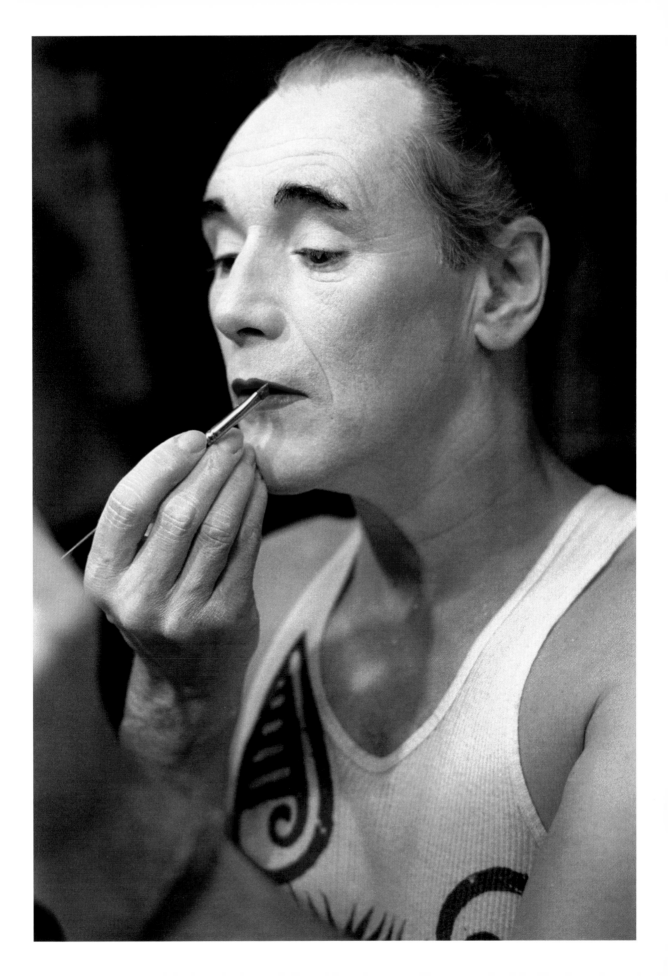

24

*"This is the moment when Mark looked up and
I realised he had transformed into Olivia.
I can see her smiling at me."* — Mary McCartney

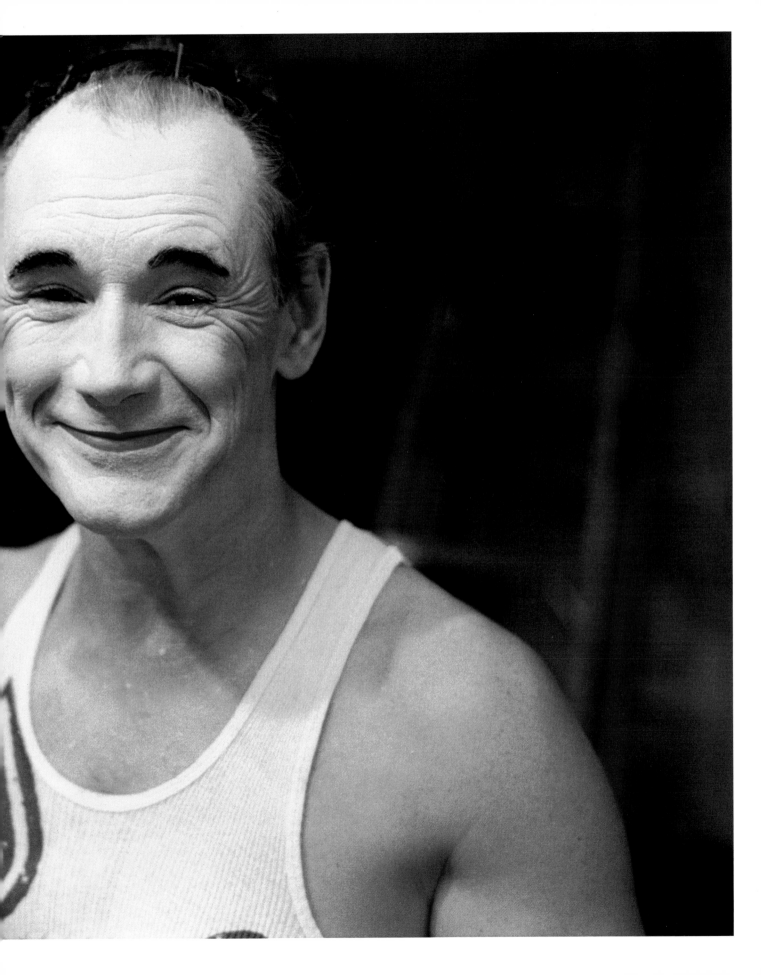

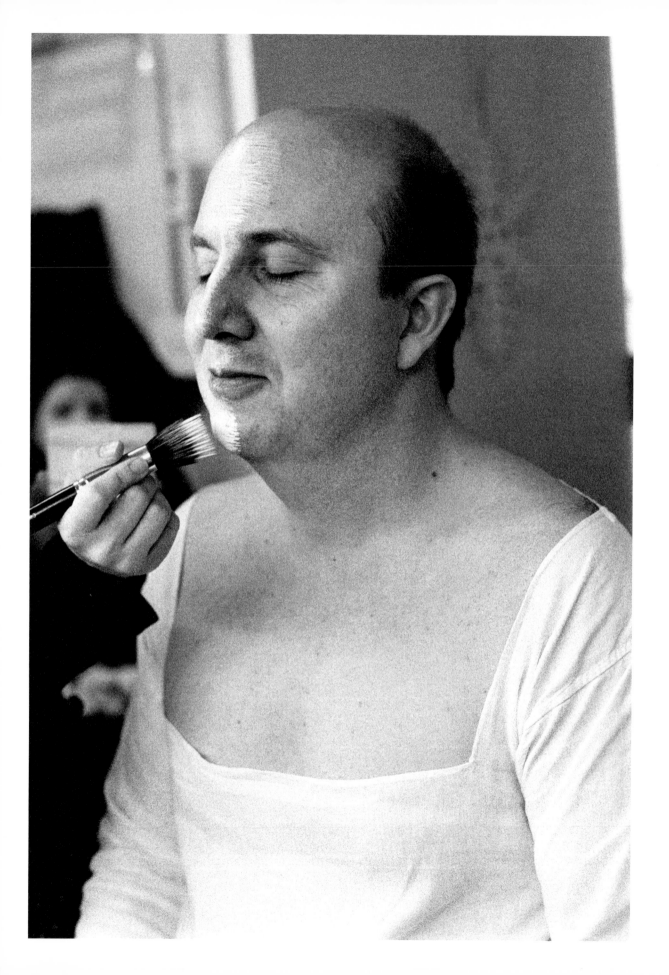

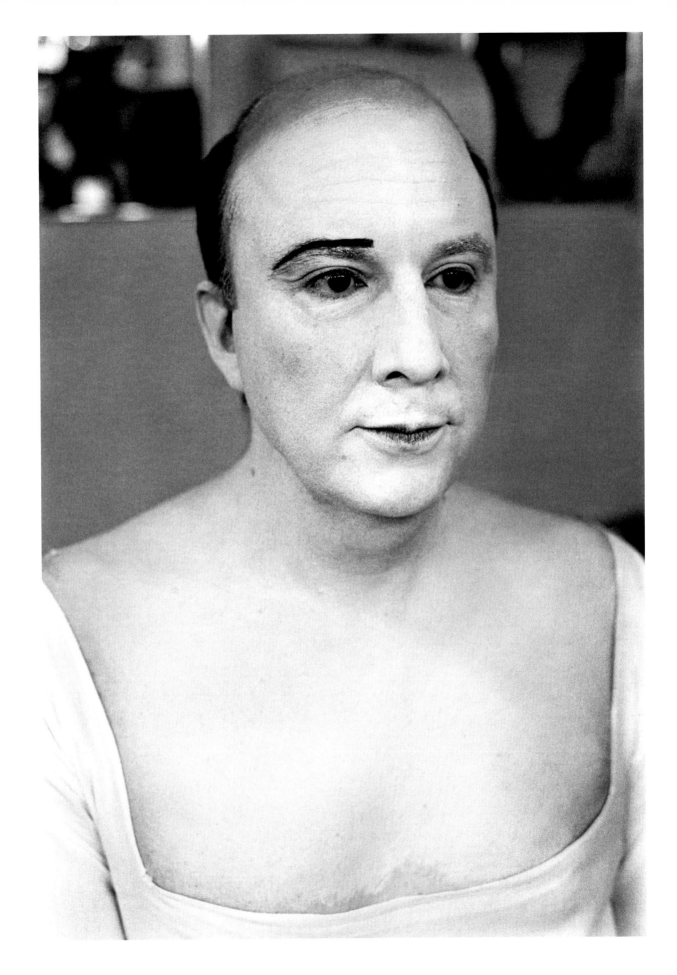

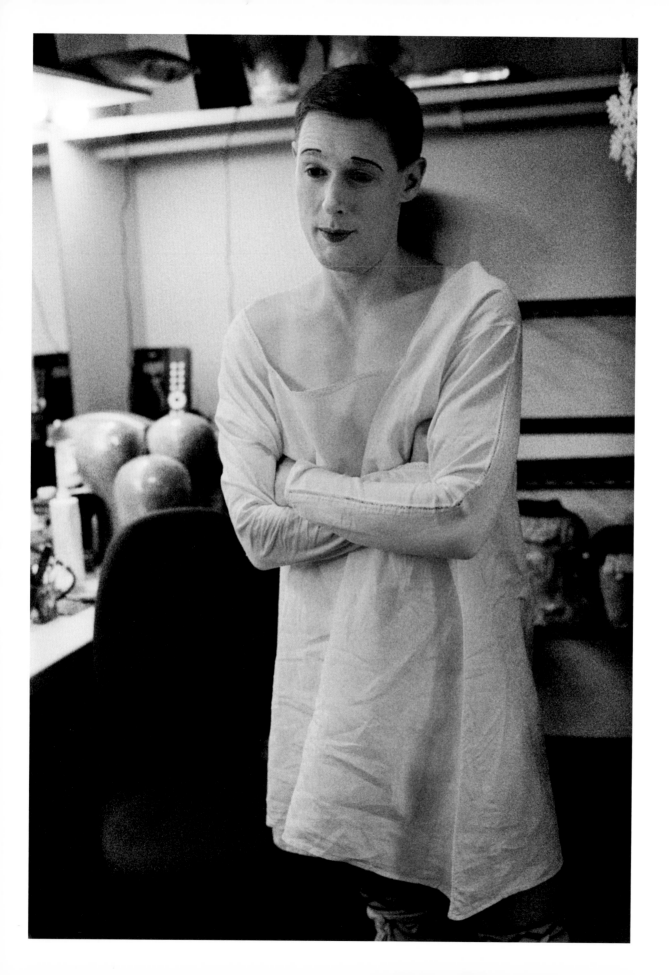

"*Dressing Mark for a role like Olivia in a Shakespeare play always feels like helping to create the character for the very first time; as though the part was written for him and we are discovering a new person.*" — Jenny Tiramani

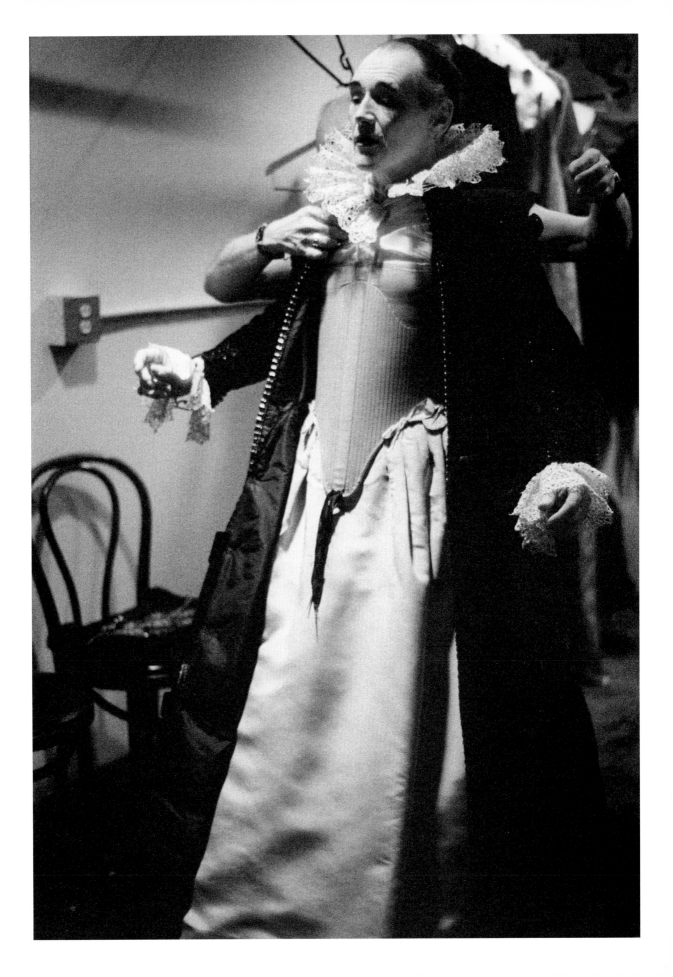

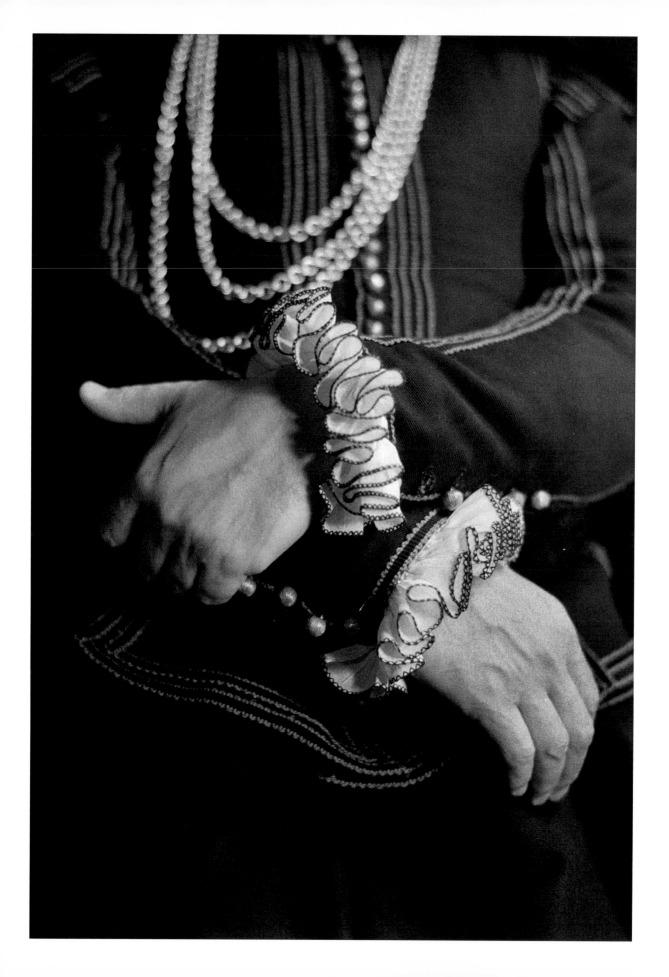

"The clothes are the work of Jenny Tiramani. She had worked solidly from 1997 to 2014 to find out more and more about how they actually made these clothes and how they were dressed. They're very, very expensive clothes, and apart from the music, the most authentic aspect of the whole thing." — **Mark Rylance**

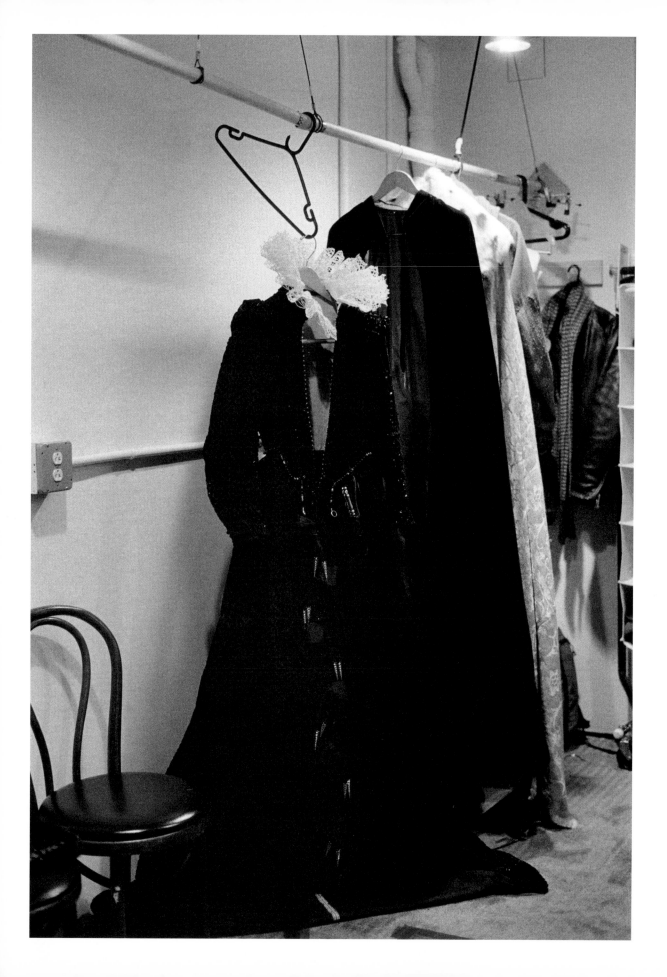

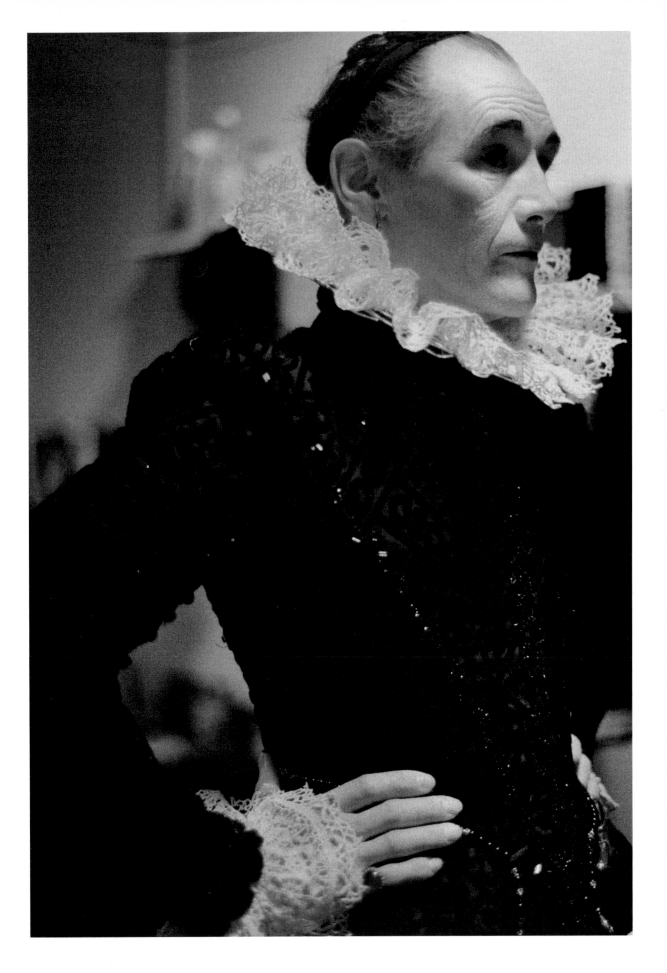

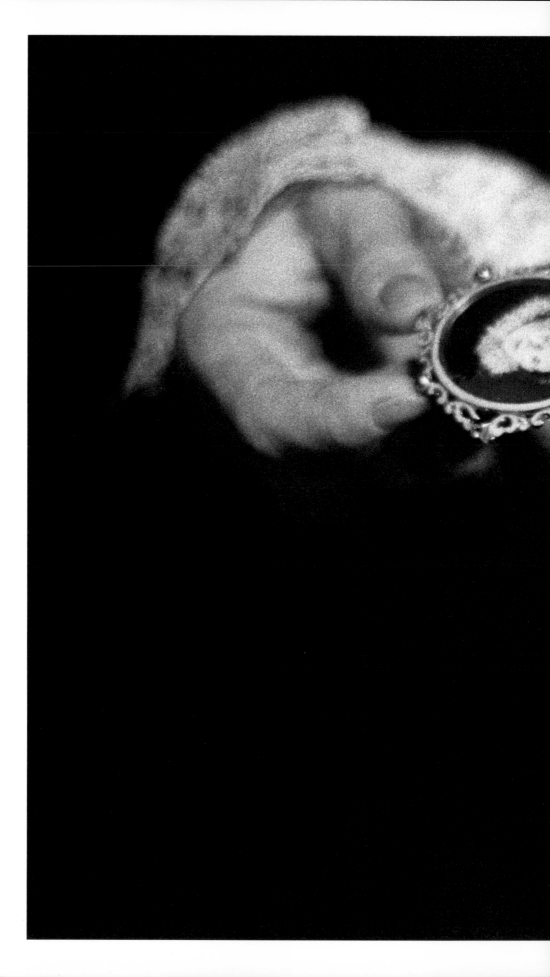

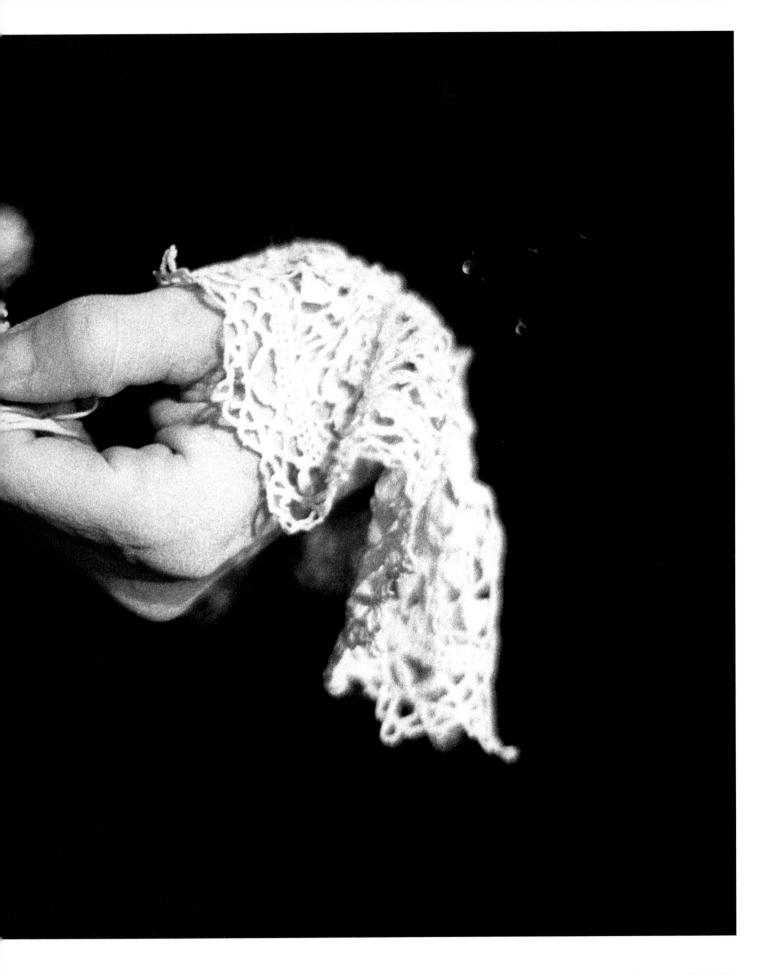

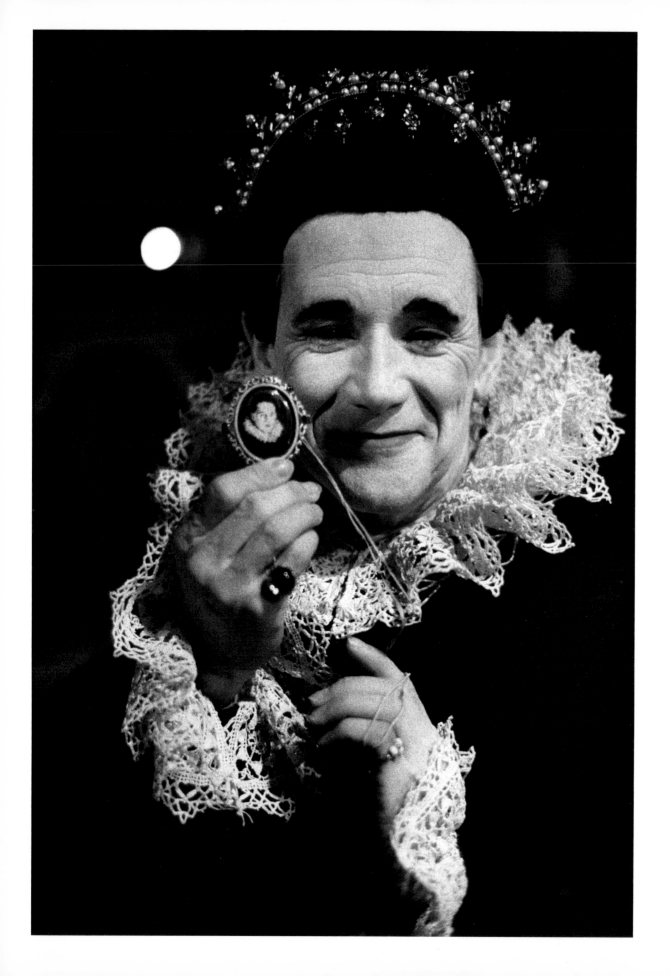

"There's the lovely little miniature that Jenny made for me, of myself." — **Mark Rylance**

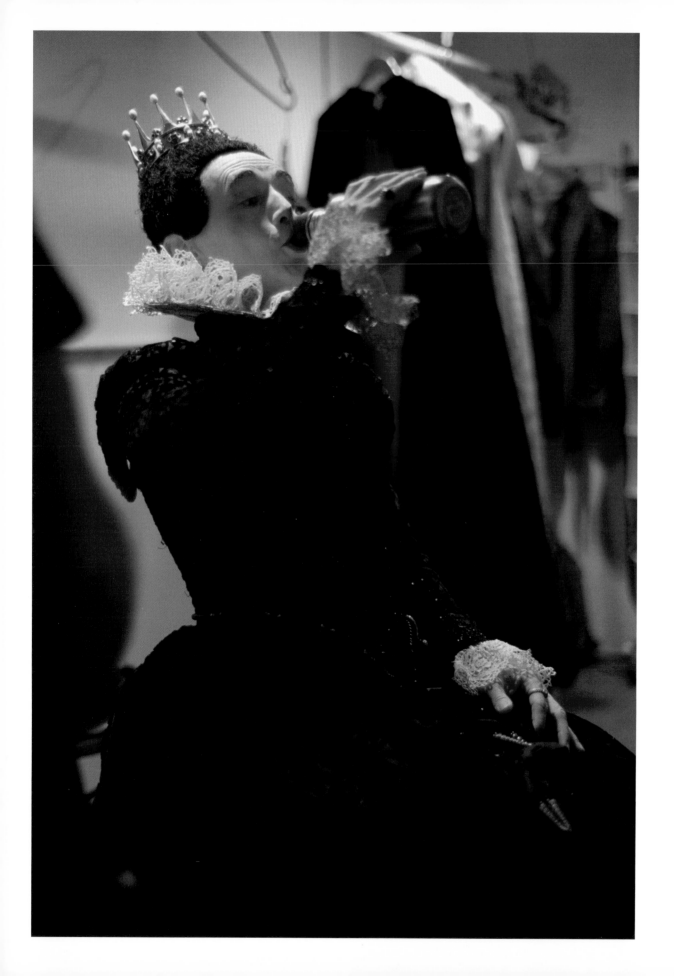

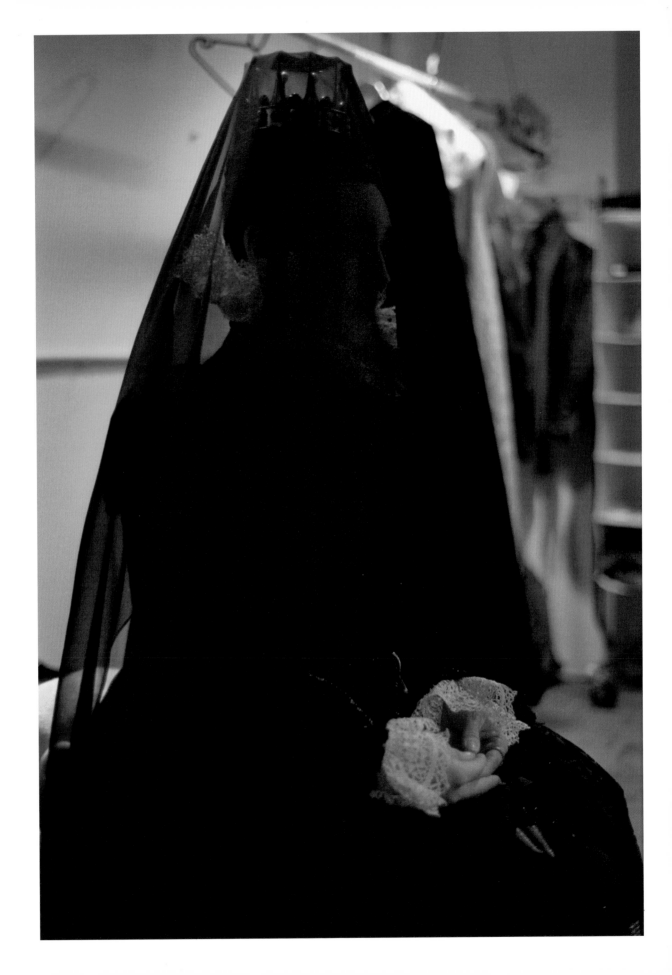

First Half

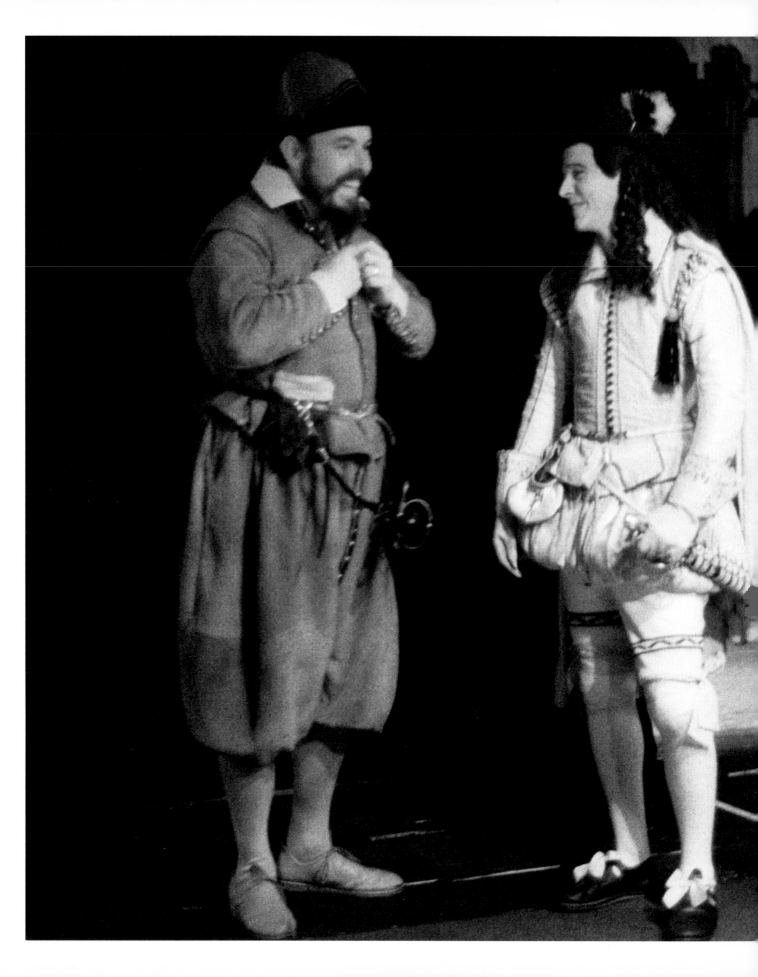

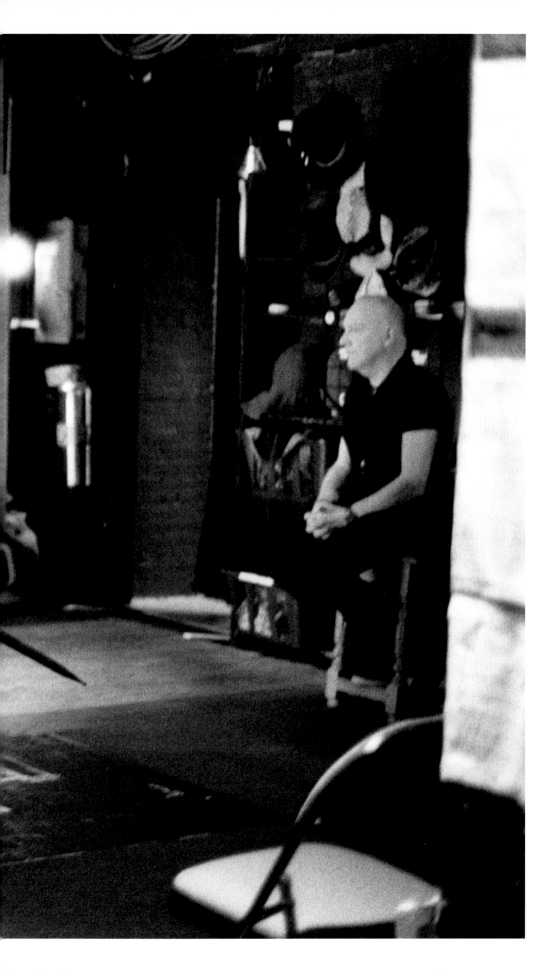

寺

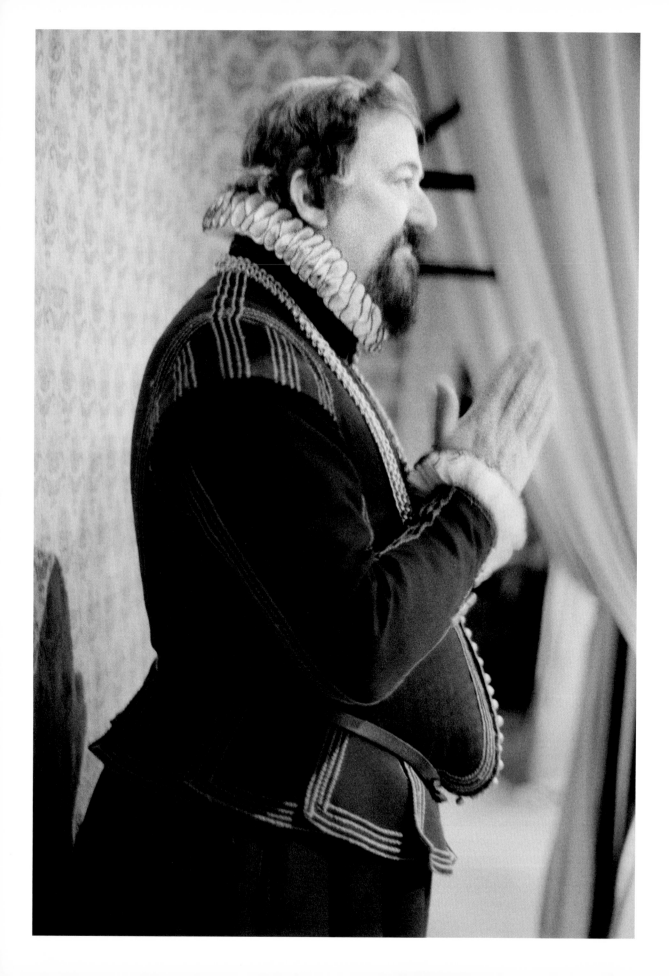

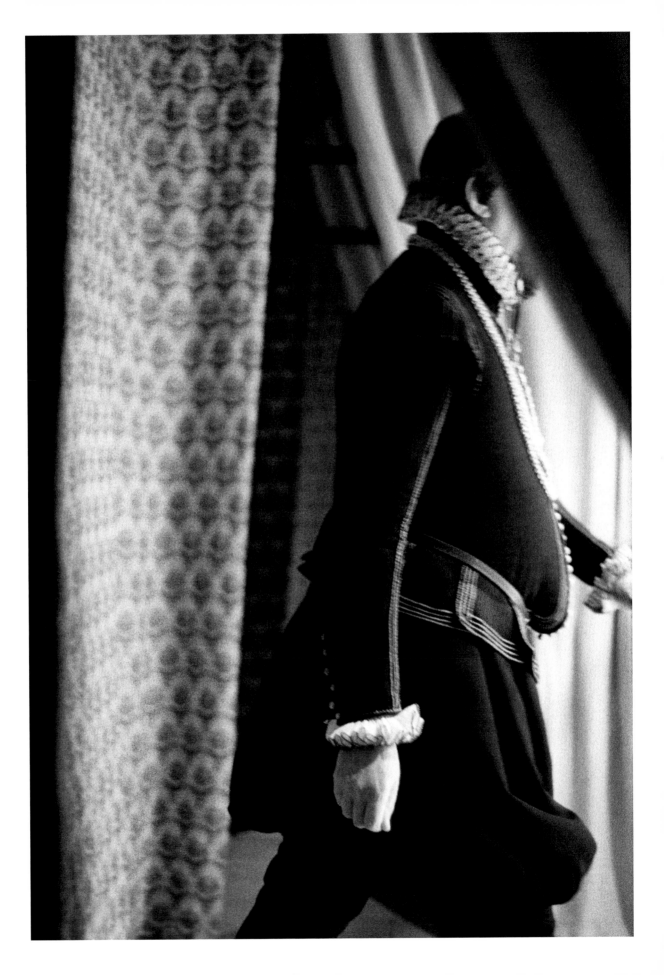

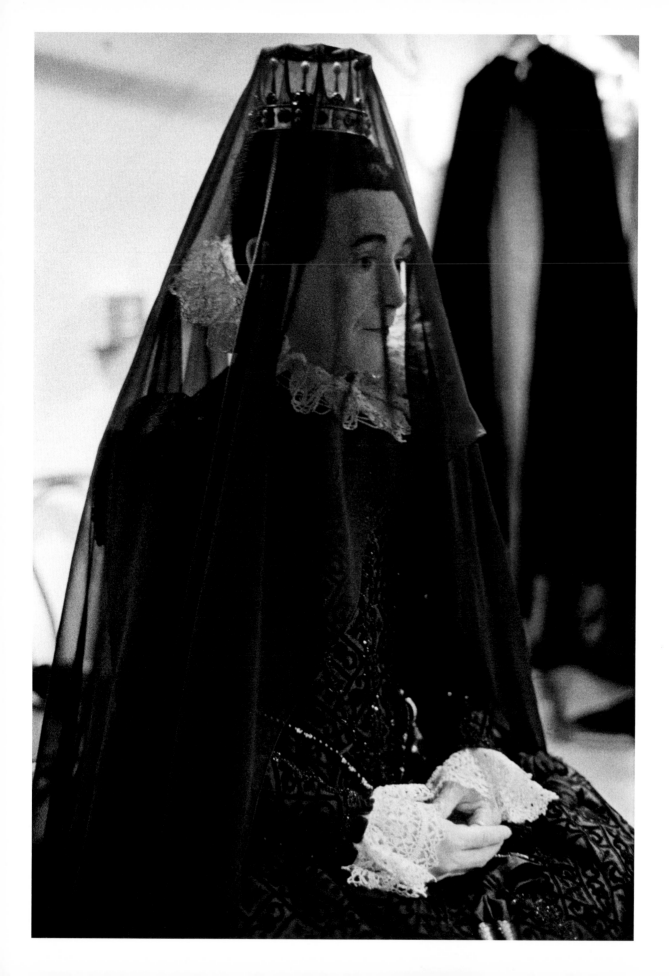

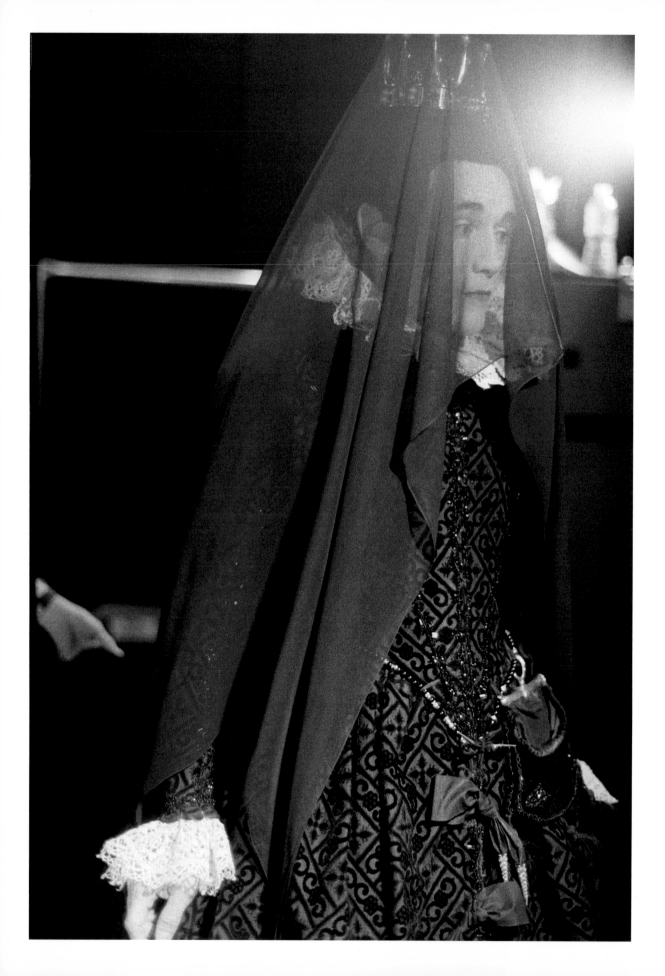

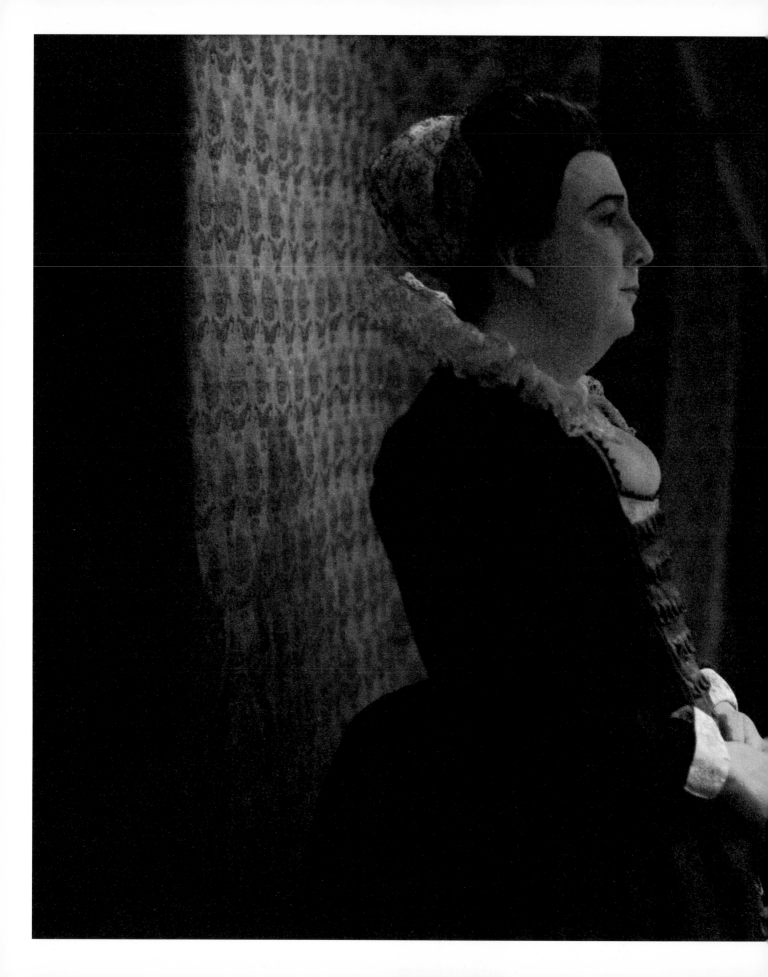

"Twelfth Night *is one of Shakespeare's most musical plays in which the* *melancholy of love is fed by a constant stream of requests for music, songs,* *catches and rounds. The* Twelfth Night *musicians played many Renaissance* *instruments between them: shawms, recorders, curtals, bagpipes, trumpets,* *sackbuts, lute, theorbo, drum and tambourines."* — **Claire van Kampen**

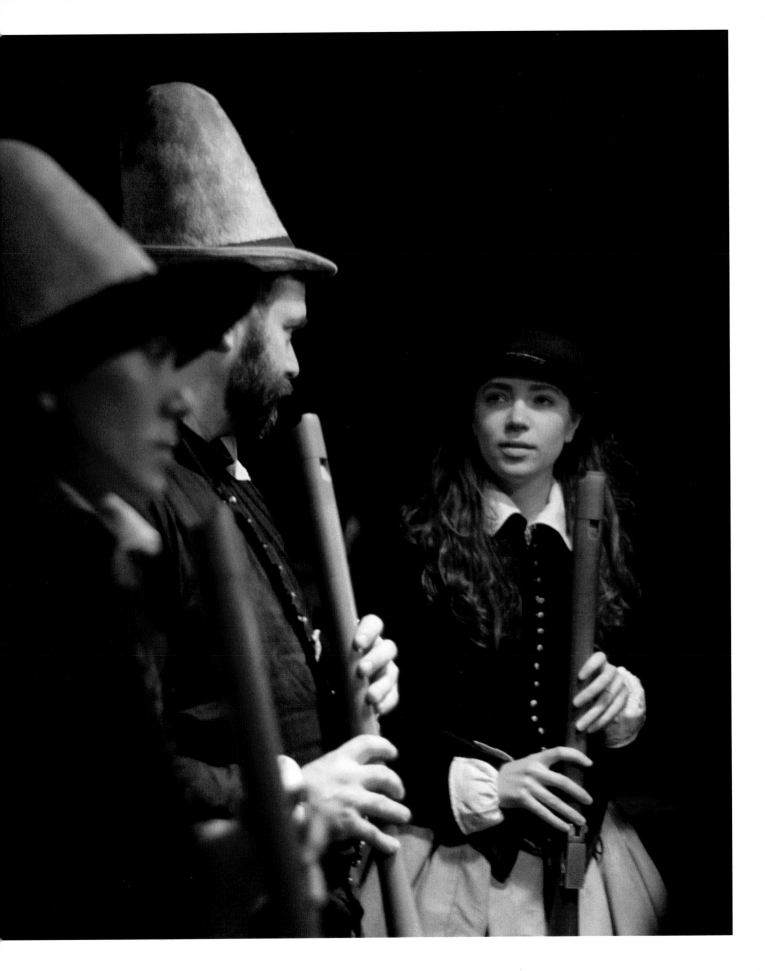

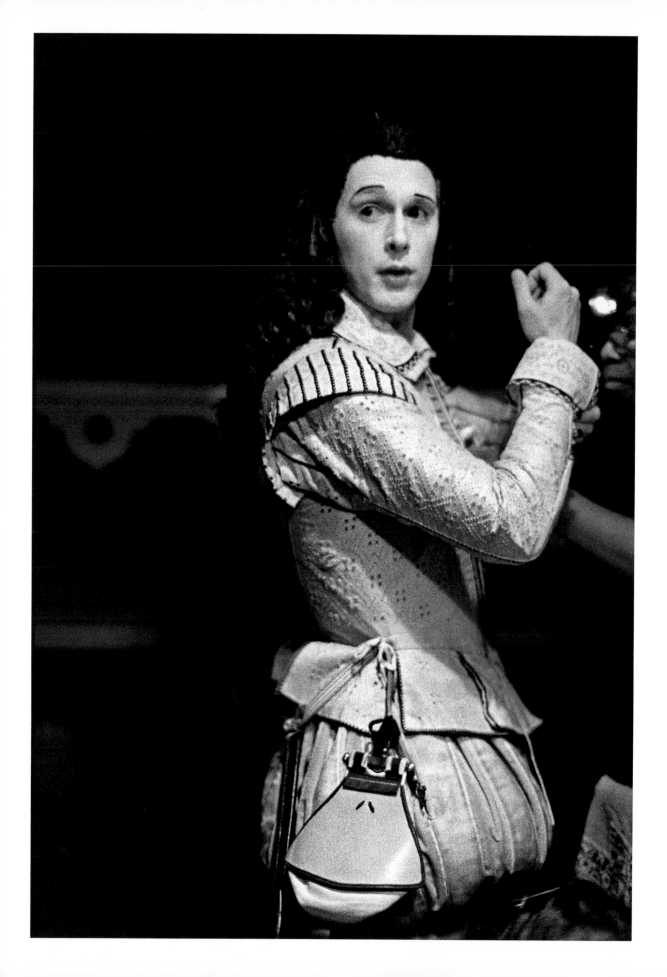

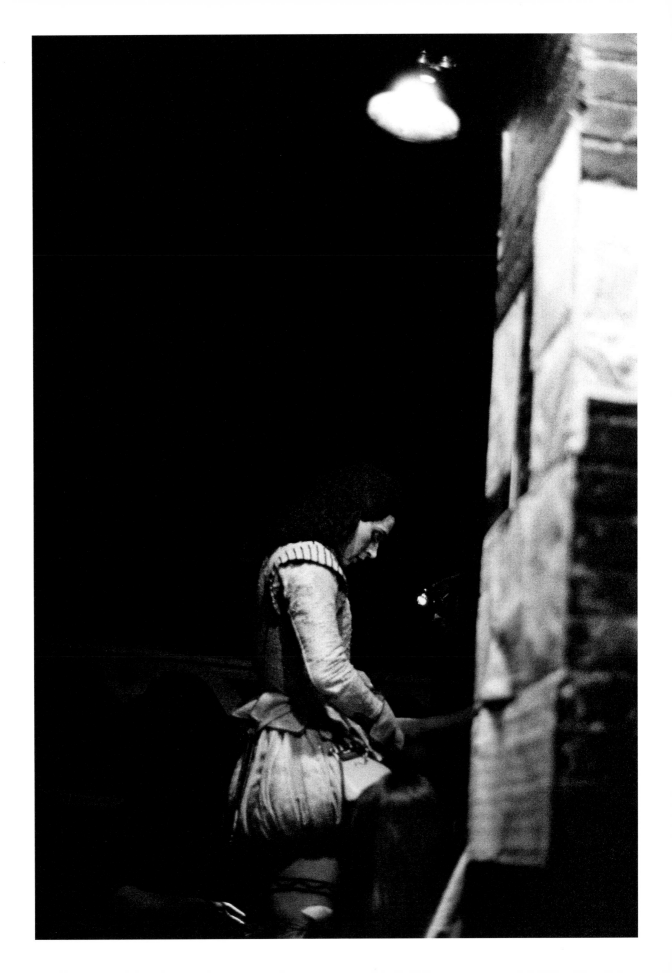

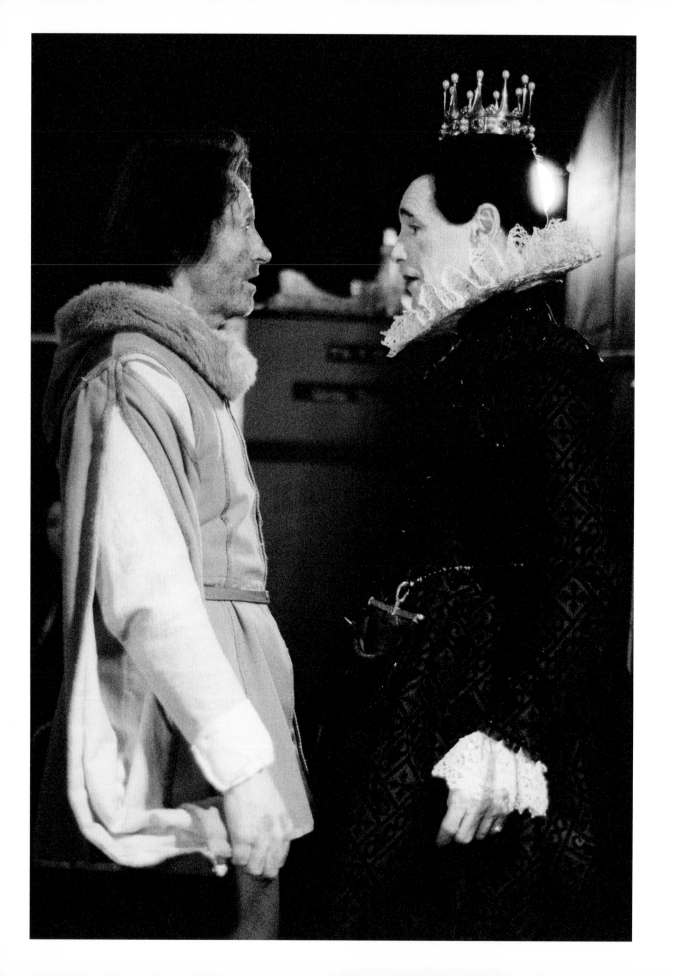

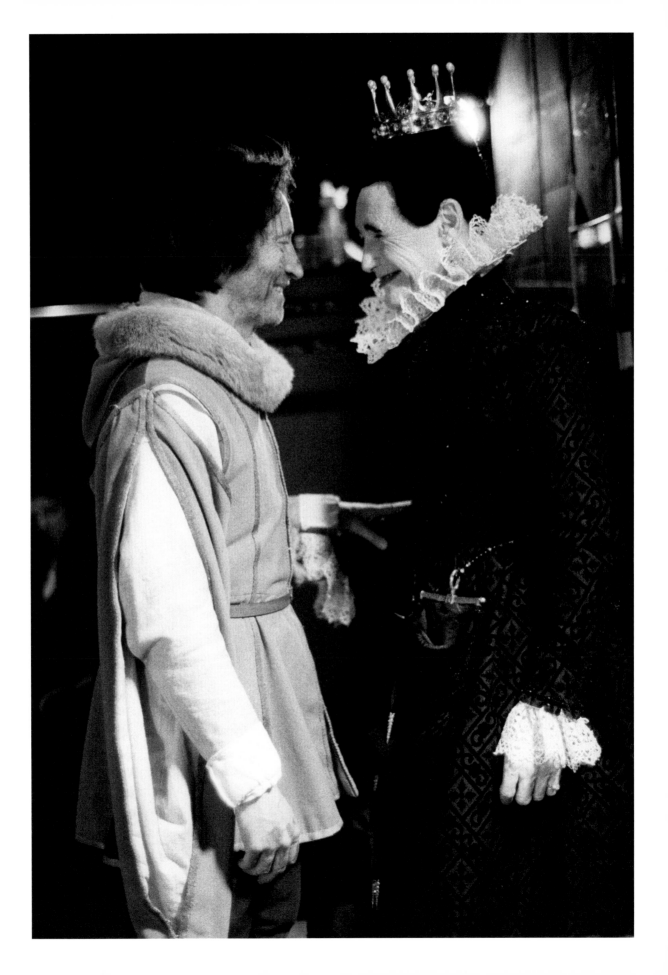

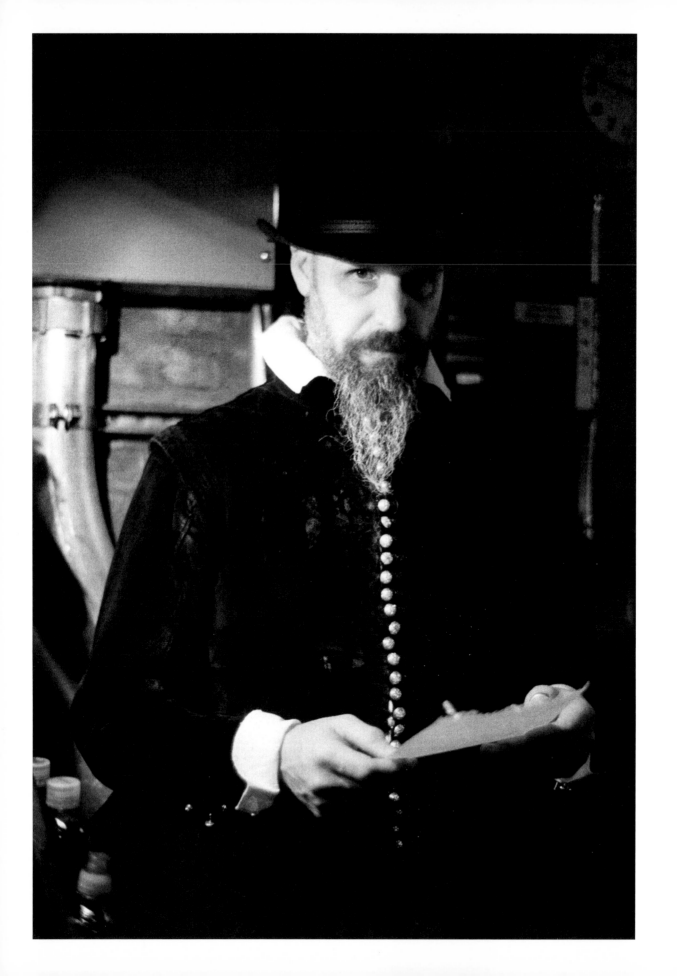

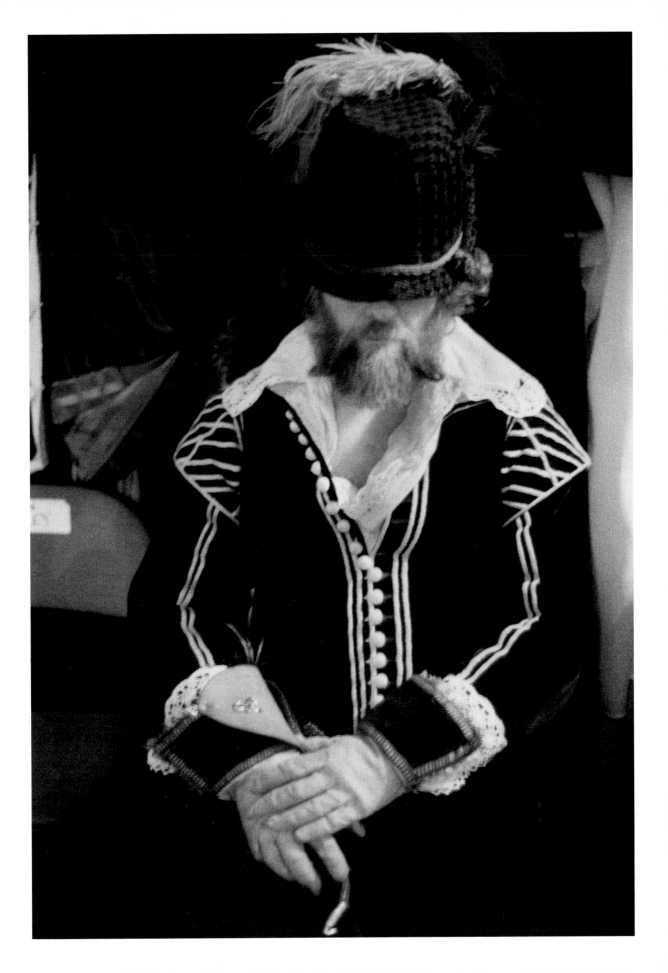

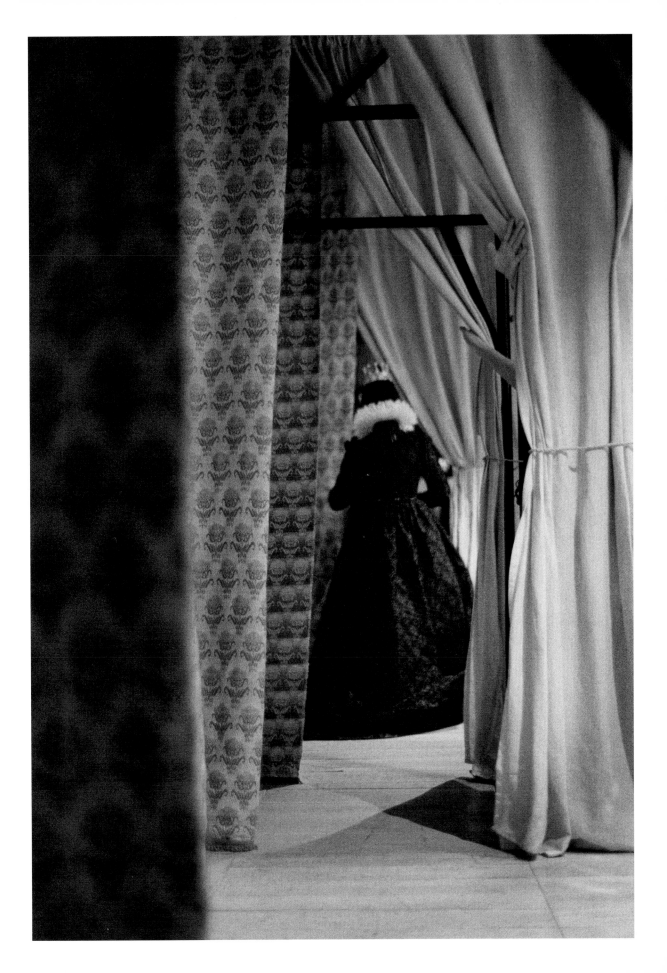

Intermission

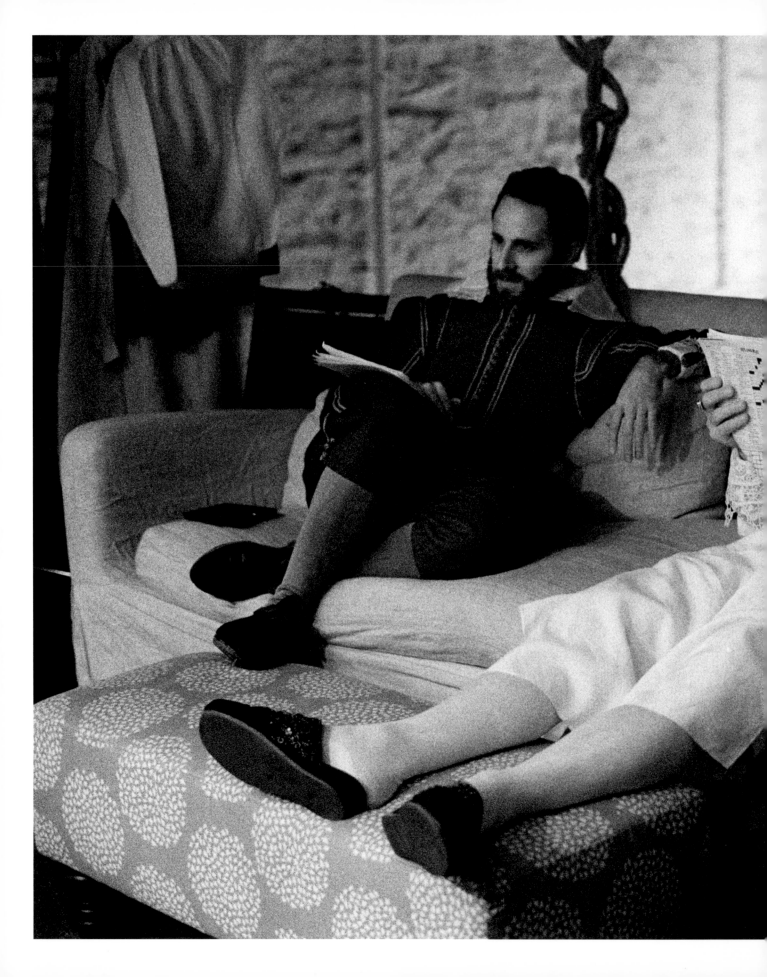

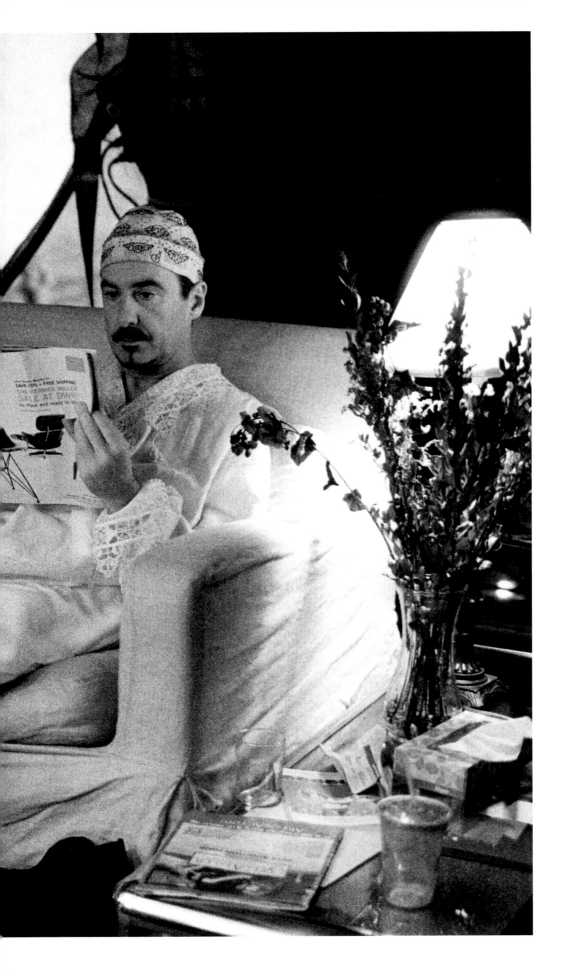

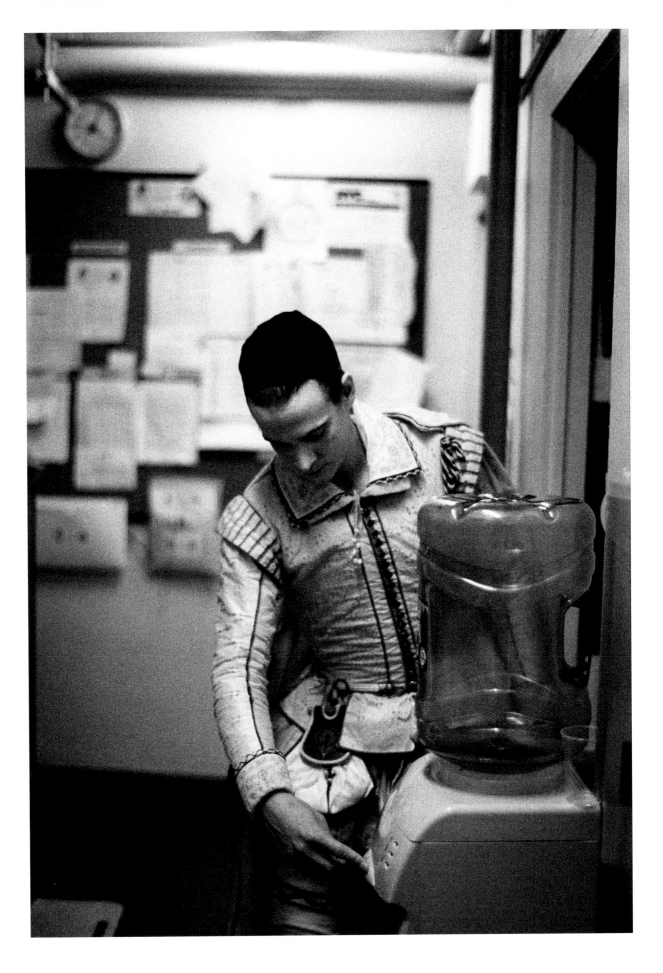

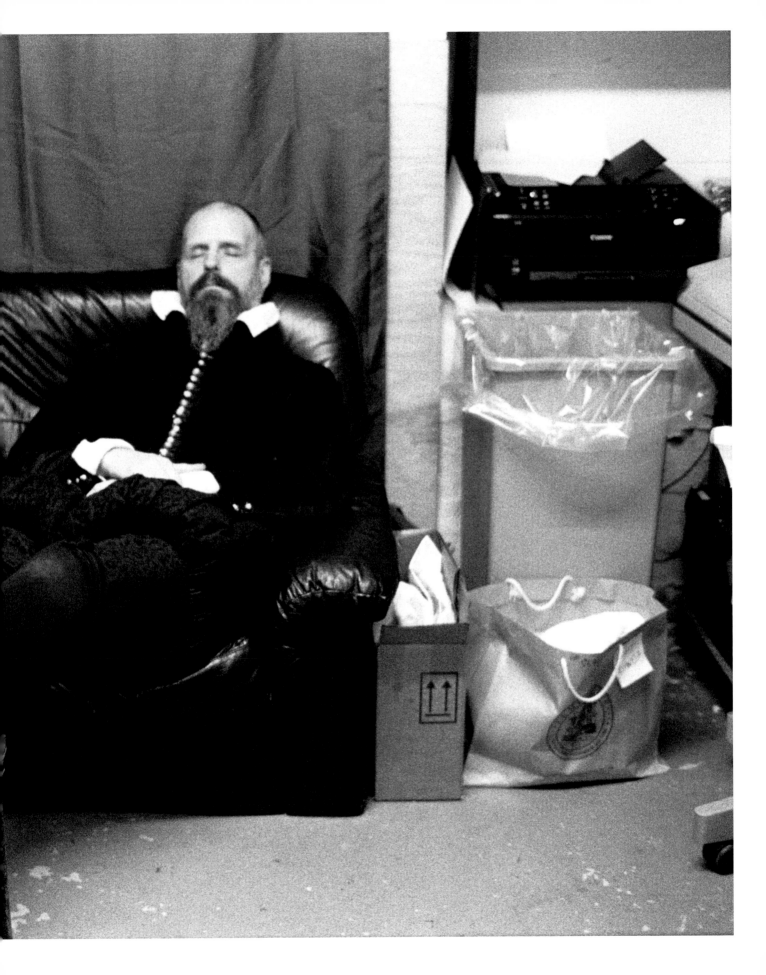

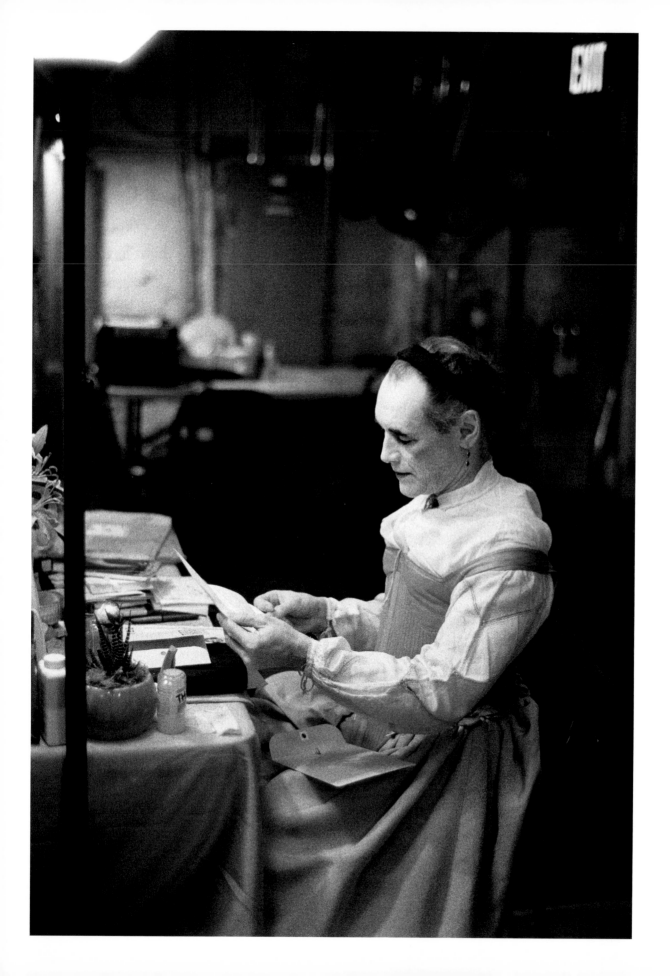

"I get lots of fan letters and correspondence when I'm in a play, so this part was very nice with 20 minutes off-stage time where I could just focus on those things." — **Mark Rylance**

"That feels like something Olivia does anyway. That's a big part of grief and of people dying, you have a lot of correspondence, wonderful letters from people, some of the most beautiful letters people may write in their lives. And you really feel that you want to respond." — **Mark Rylance**

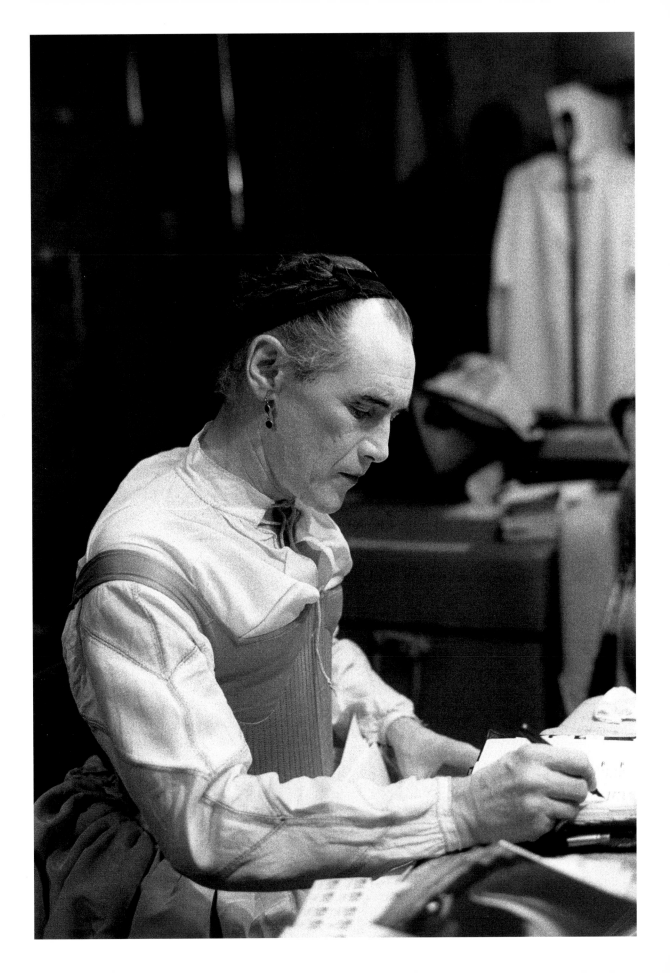

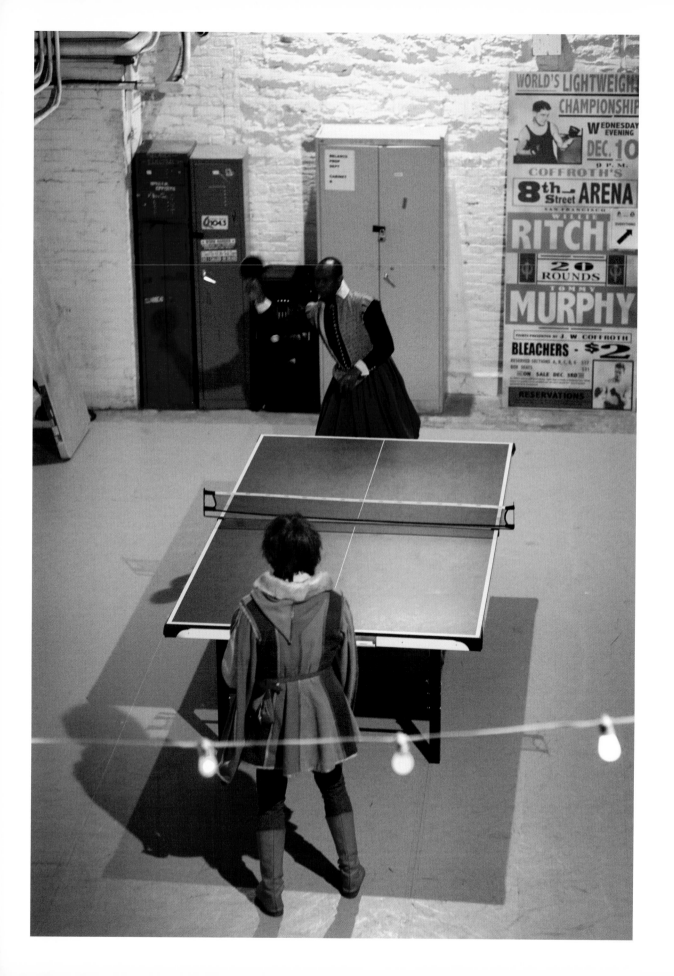

"Backstage I remember fondly the large basement (built originally to house a trick involving a disappearing elephant that Houdini was supposed to perform at the Belasco) in which we had table tennis competitions, ate food betweens shows, and created a little English pub for ourselves, a home away from home, complete with beer on tap." — **Samuel Barnett**

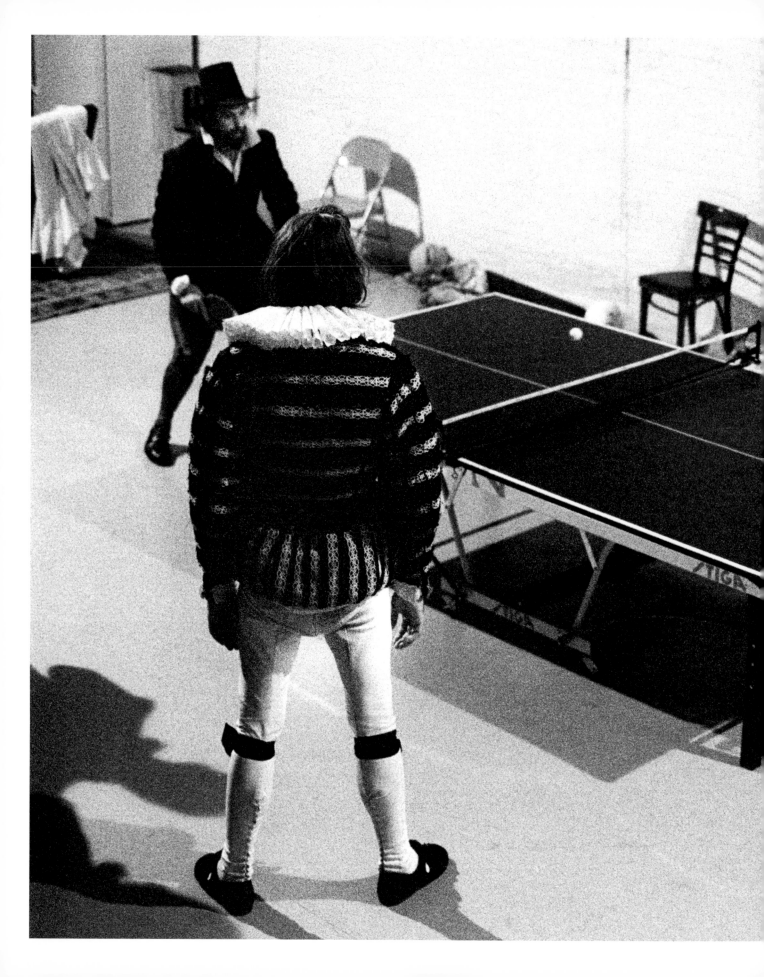

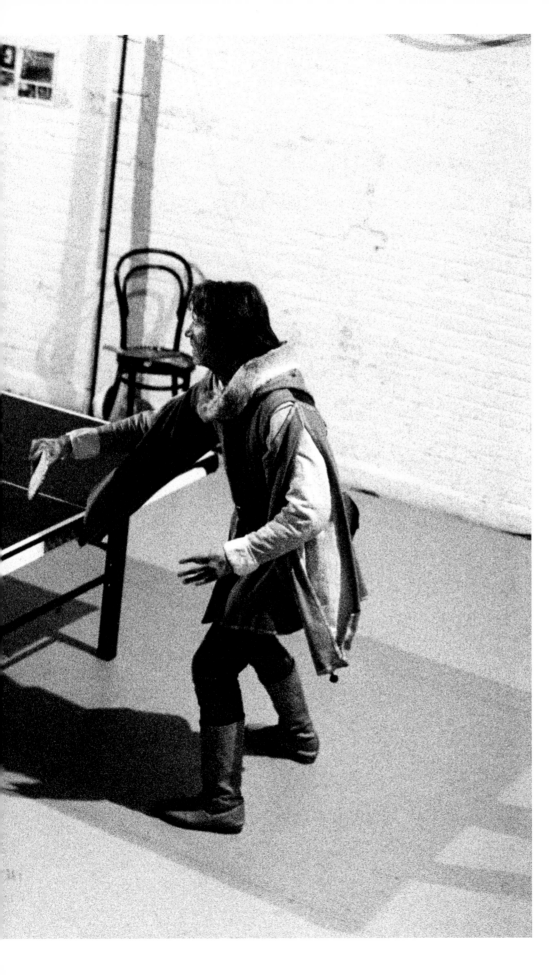

Second Half

90

"I have 15 minutes before I enter again, after dressing onstage, for Act II, which is where Olivia is wearing something a little bit more flirtatious, I think. This is more formal. She's been sworn to mourn for seven years. She'll walk in her garden and water it with her tears. She's committed to no one looking at her for seven years, so when Viola/Cesario says 'let me see your face', it's a very great thing that she allows him. She is breaking her vows by doing that." — **Mark Rylance**

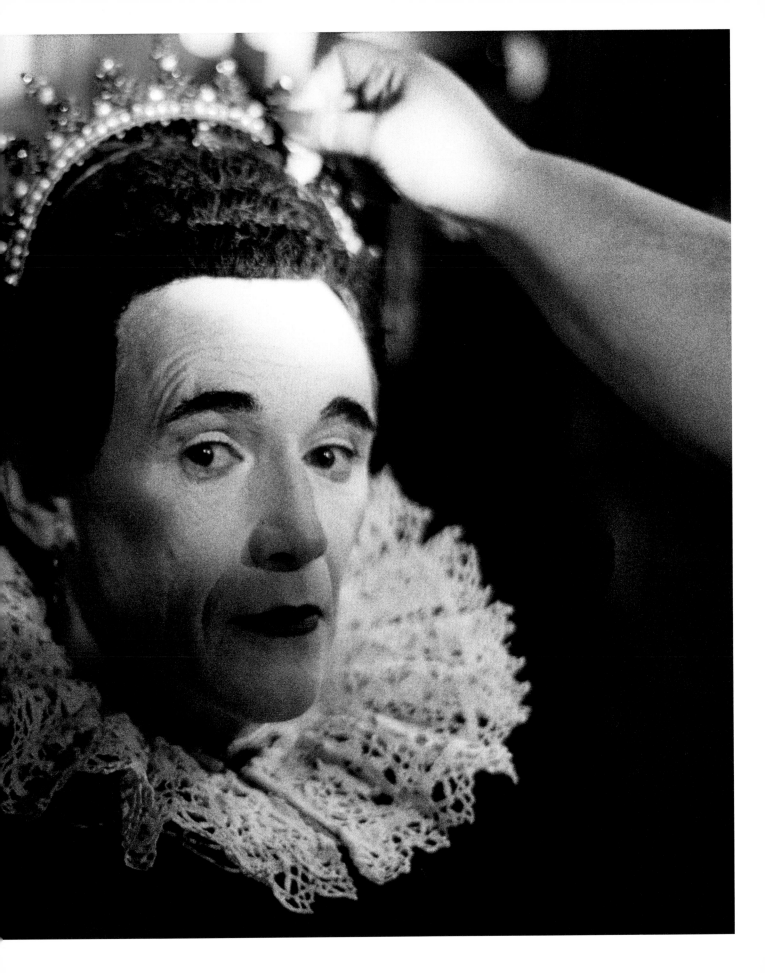

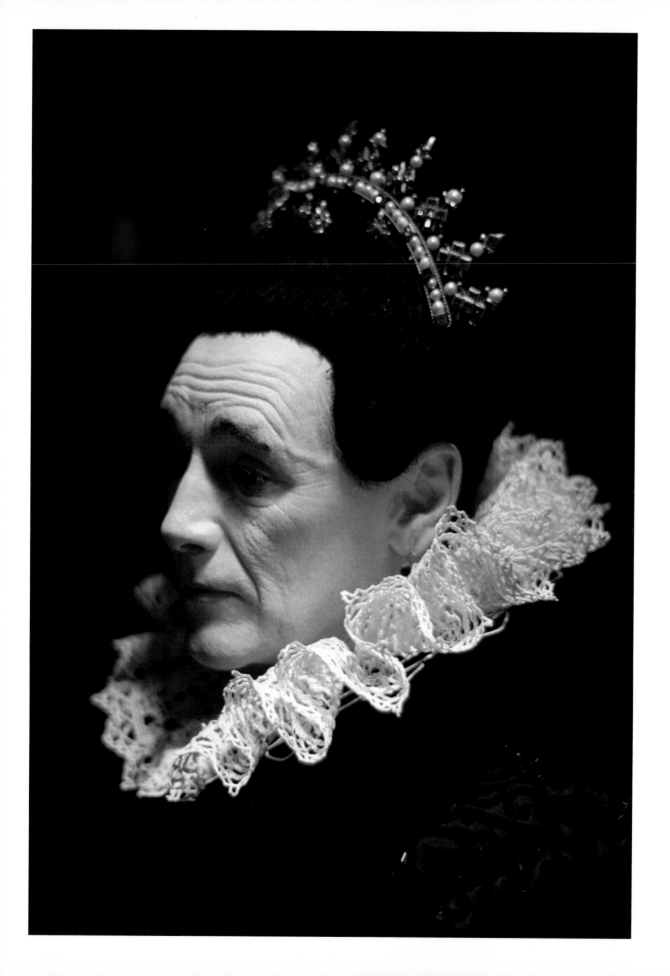

"It was a proper cast ensemble, we'd been together for ten years, so we knew each other, and we knew each other's weaknesses and strengths. It was a very loving company in that way." — **Mark Rylance**

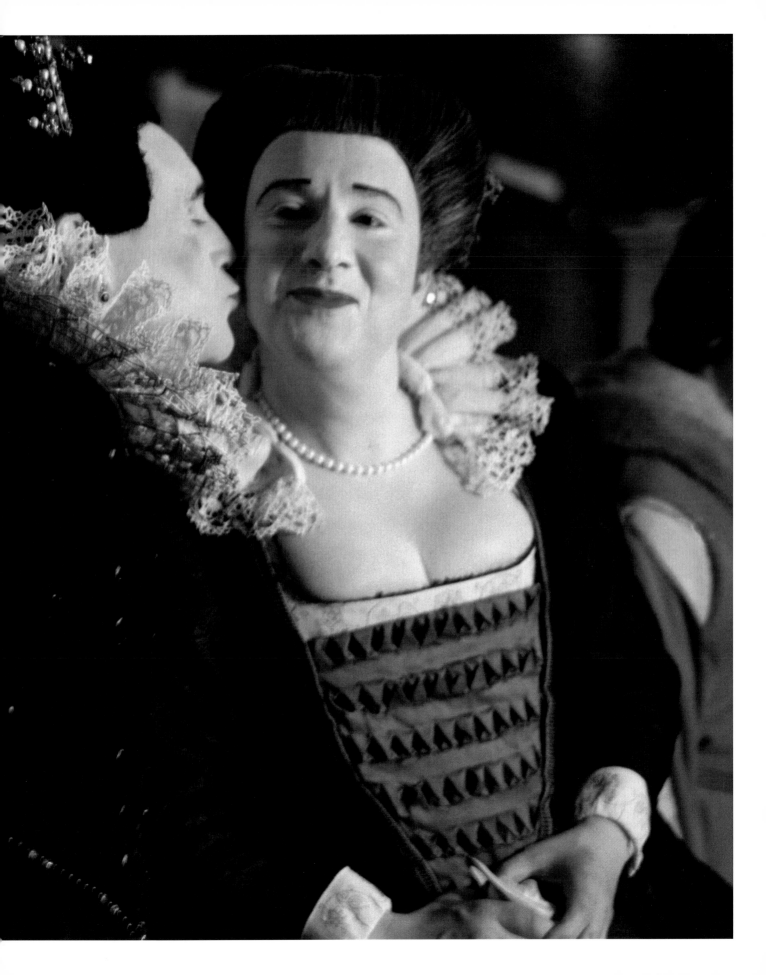

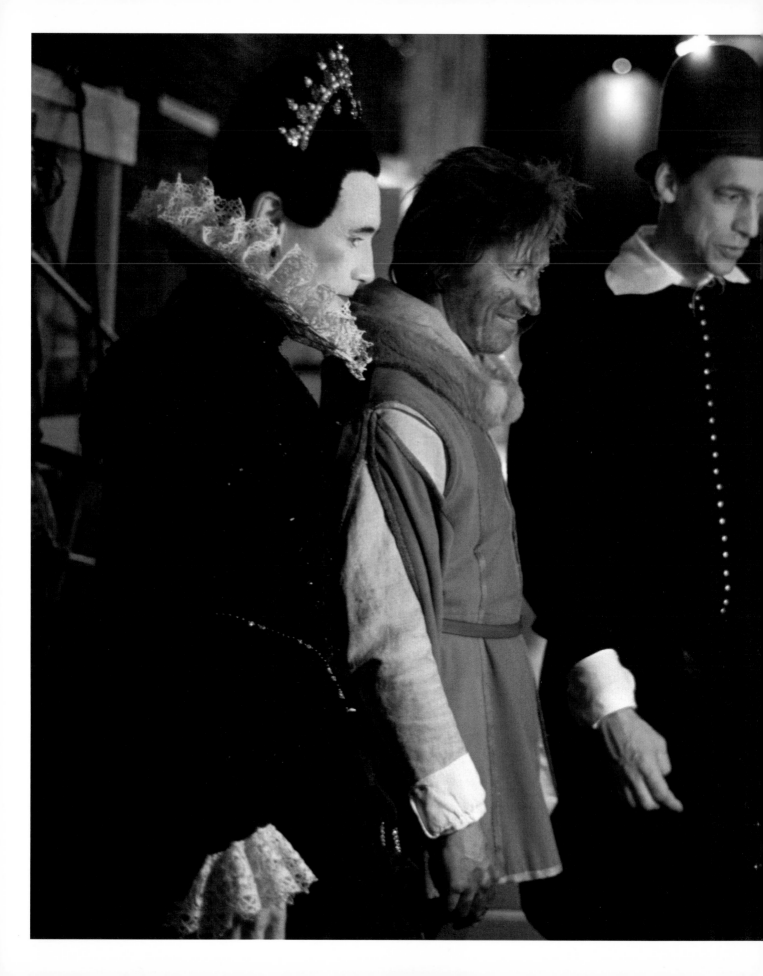

"During the performance, I was struck by the instant juxtaposition of old and new. The cast, in costume, was watching a Liverpool football match live streaming on a laptop in the wings directly behind the stage." — **Mary McCartney**

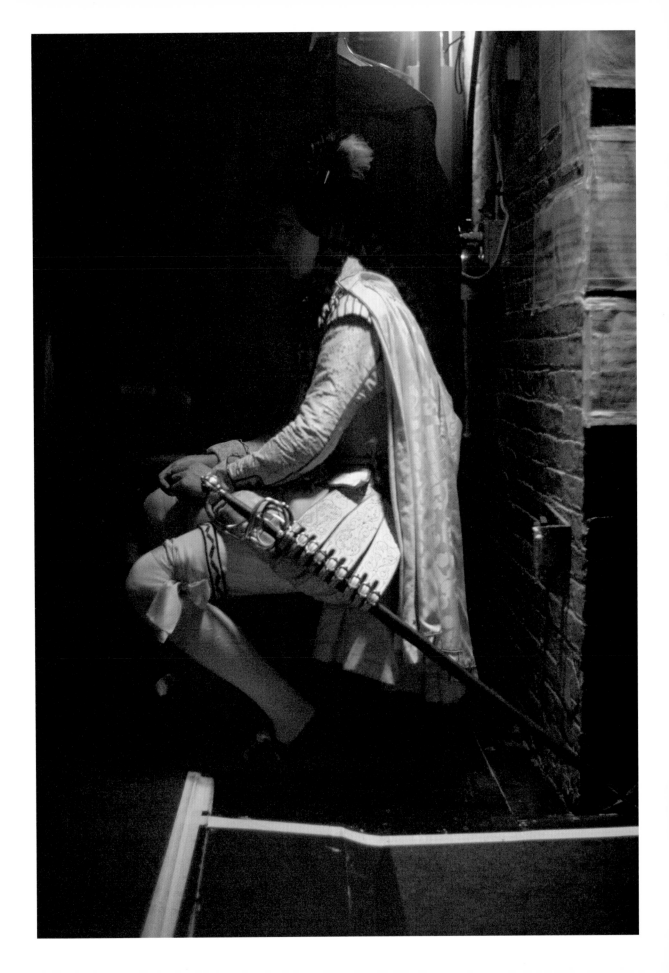

"We lived, laughed, dined, danced, drunk, cried, pinned and survived together, in each other's pockets for three months." — Joseph Timms

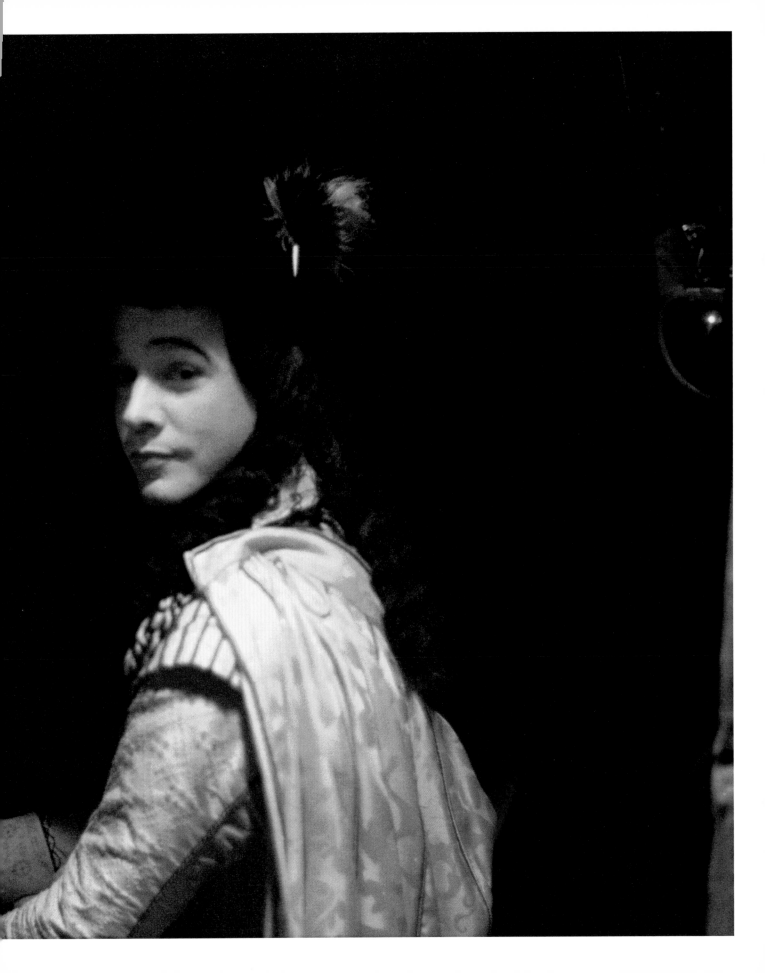

"This is for the last scene, where Stephen Fry's character has been in prison and he looks a mess, they think he is mad." — **Mark Rylance**

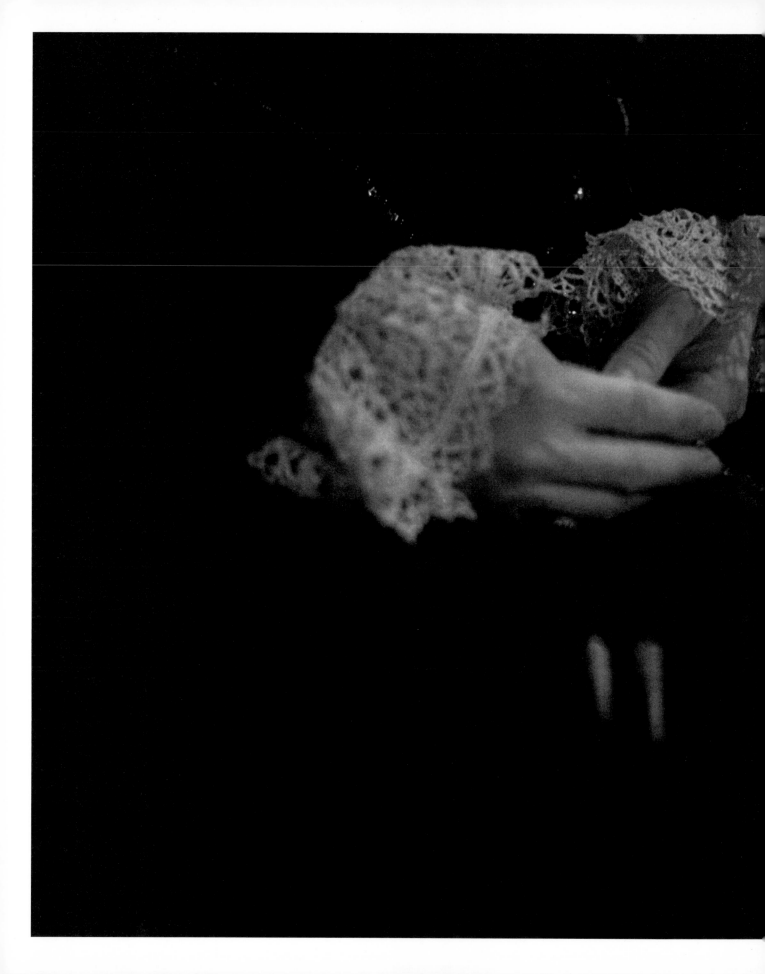

*"A lot of the work for me is bending my hands back.
This makes a huge difference to reveal the softer side.
Also, the hands need to be as small as possible.
It's a lot to ask the audience to accept you as a woman.
I'm really changing my rhythm to a different
rhythm with her."* — **Mark Rylance**

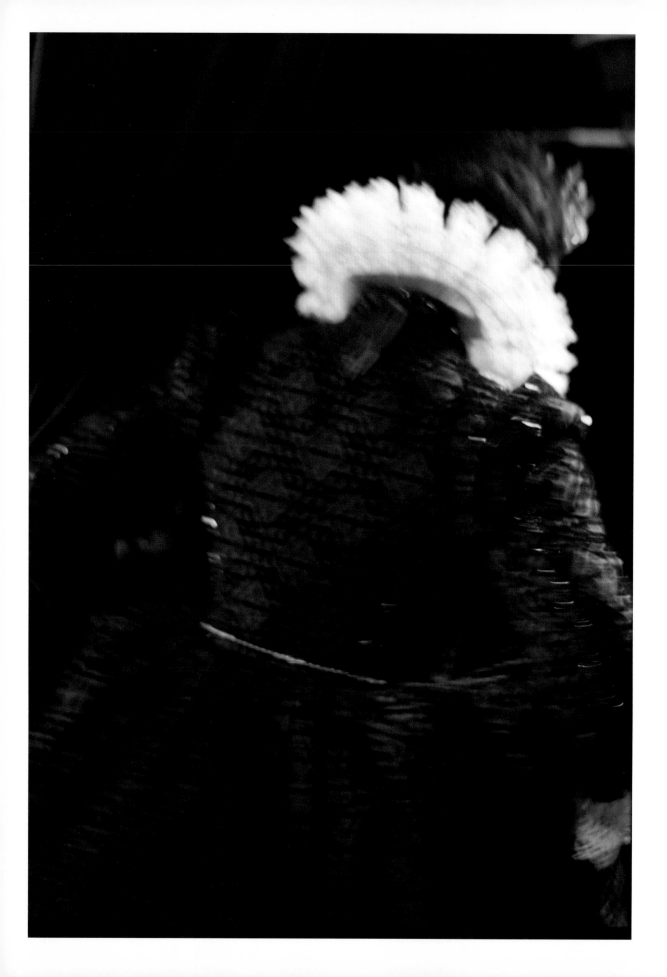

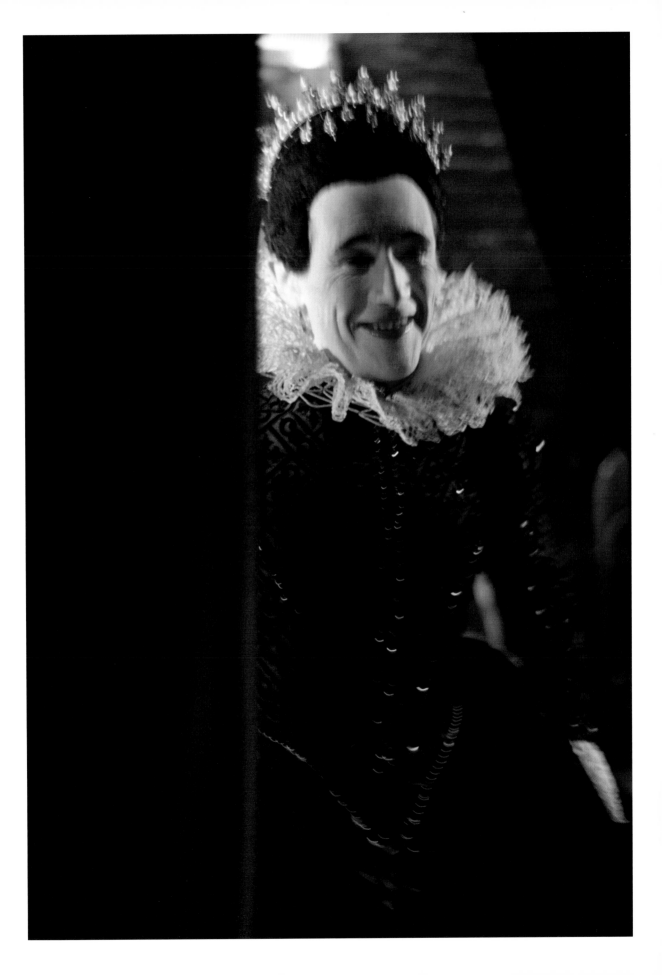

Post-Show

"I always close down and just give a kind of little prayer of thanks at the end, backstage, before I go down and join in the dressing room frolics." — **Mark Rylance**

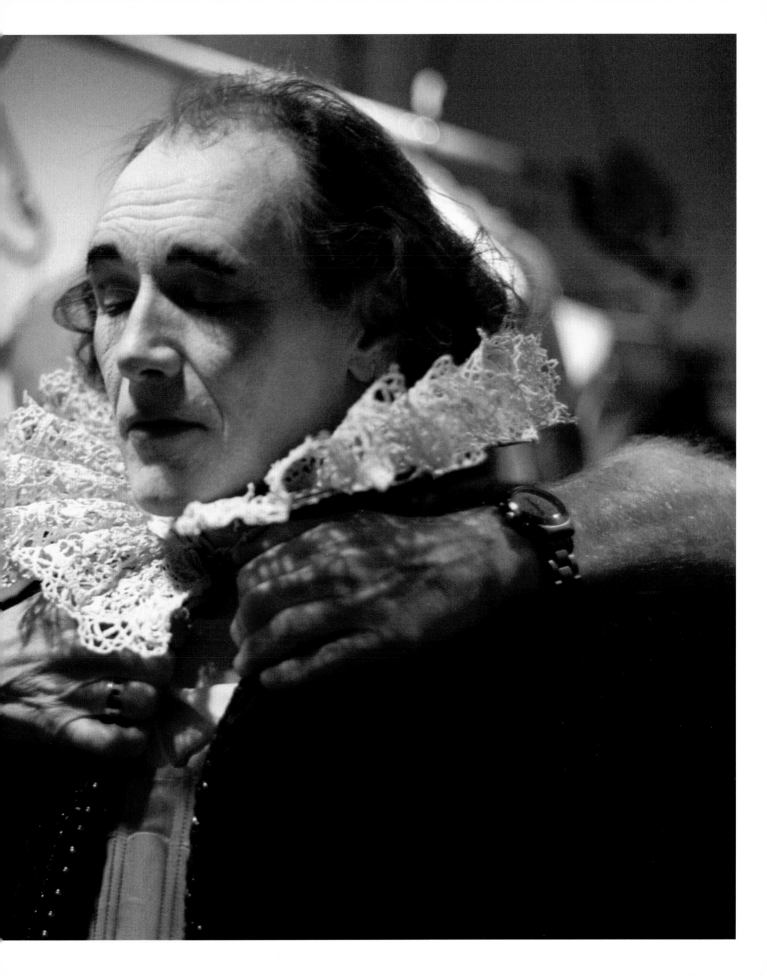

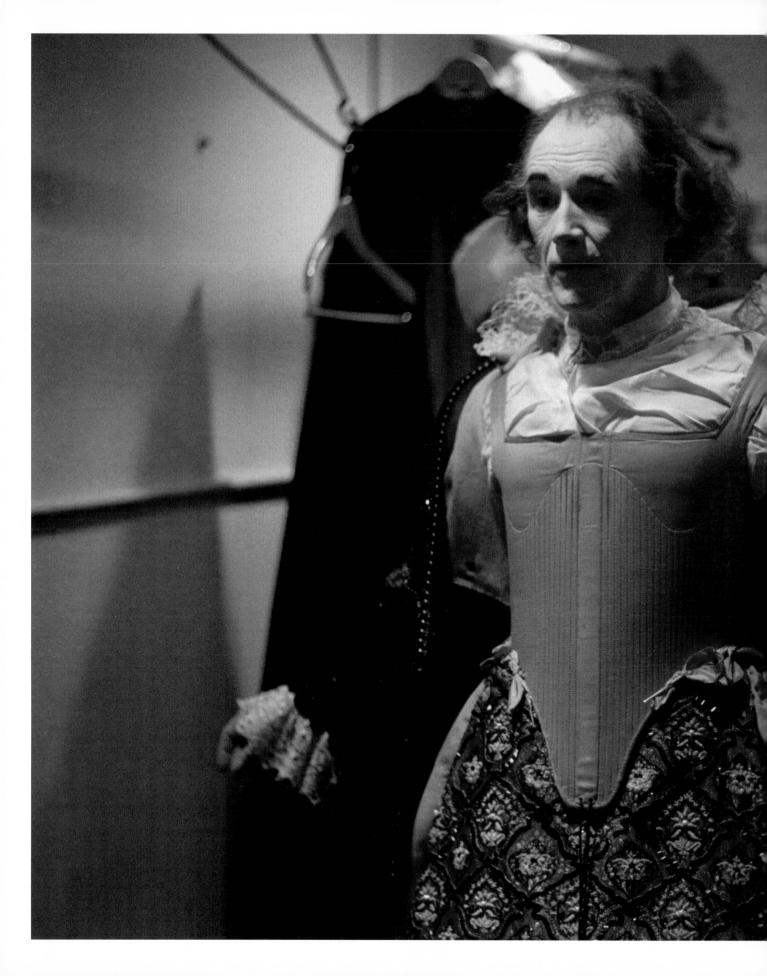

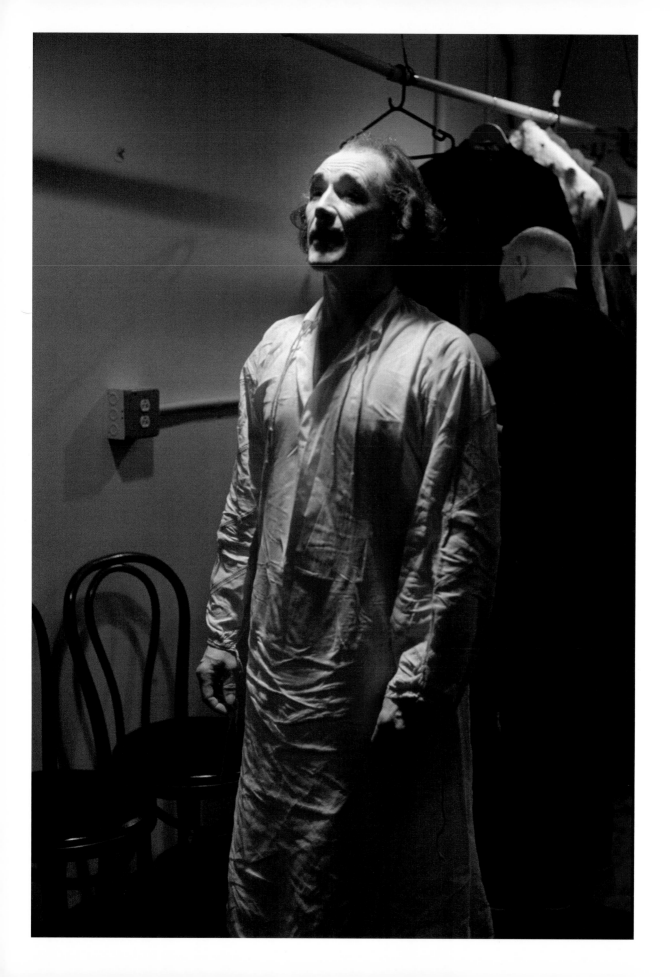

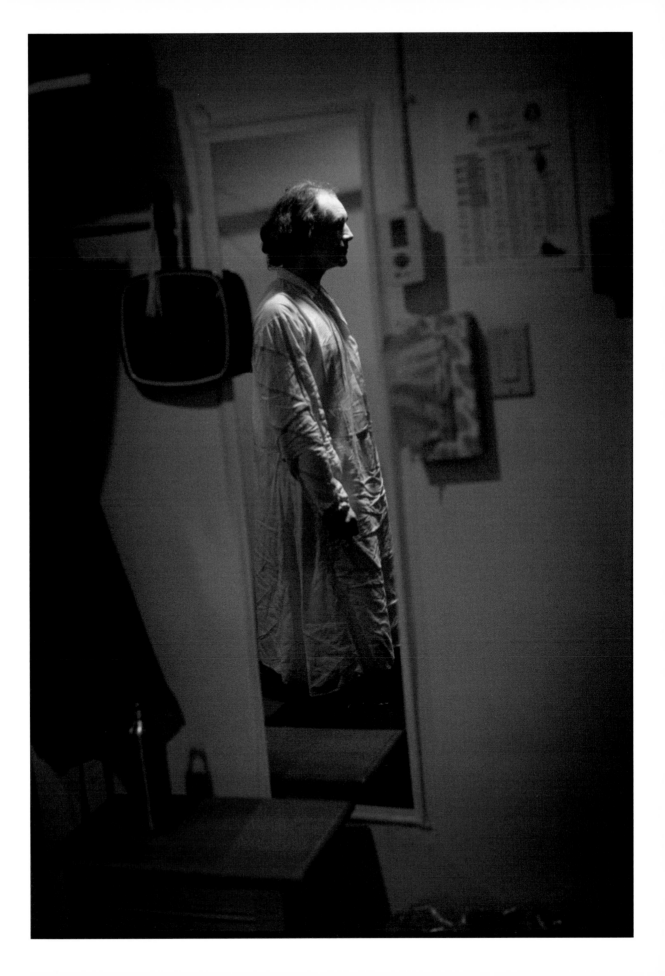

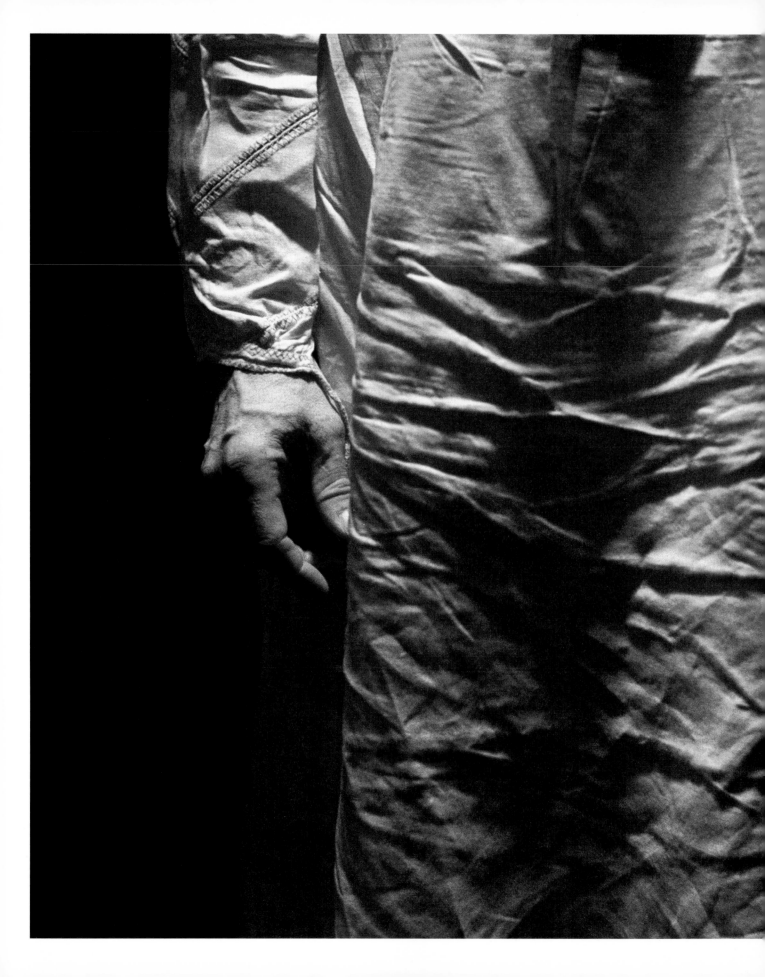

"Everything creased, directly underneath the corset; my hands look more masculine again." — Mark Rylance

"What I remember most of all is the roar of the audience at the end of the show, like a wave washing over the stage, and the sound of chairs being flipped up as people spontaneously stood to applaud. It's a magical feeling because you can't manufacture that response from an audience, so you know it's a genuine response of appreciation and joy." — **Samuel Barnett**

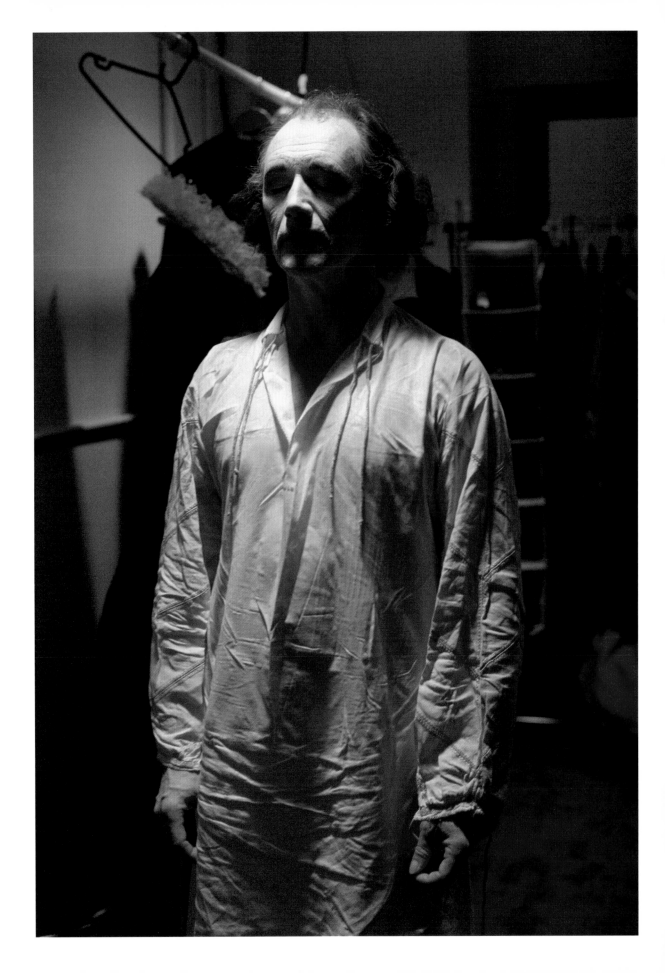

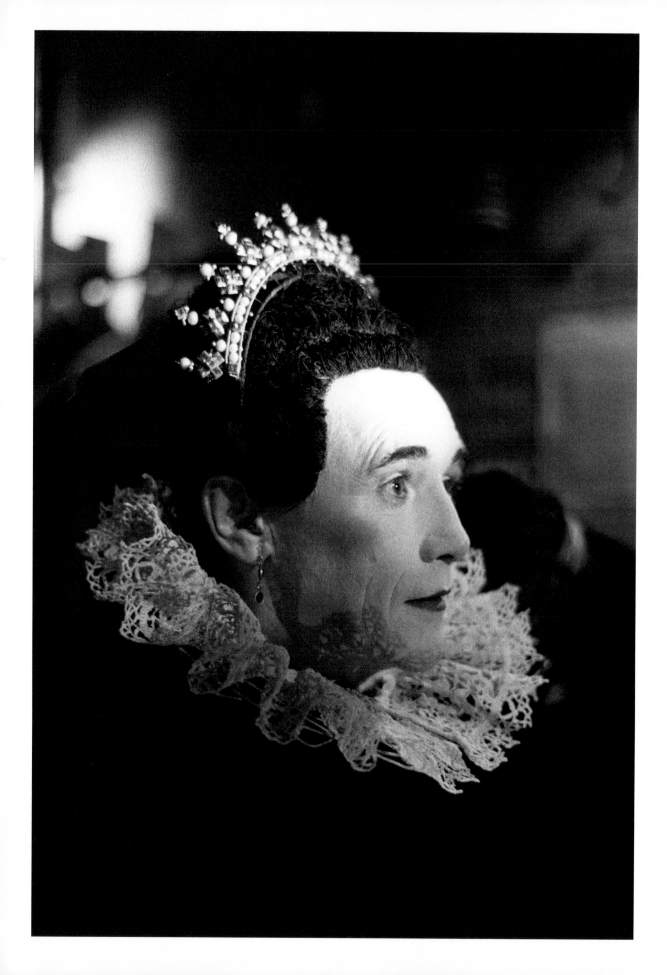

Closer to the Magic
by Farah Karim Cooper

In 2002 an all-male cast dressed in a striking array of carefully crafted Renaissance clothing performed Shakespeare's festive comedy *Twelfth Night* at Middle Temple Hall (an Elizabethan hall in London). This performance was designed to commemorate the 400th anniversary of the play's first recorded performance there in 1602, as documented in the diary of a law student John Manningham. This unprecedented performance event demonstrated the commitment of Shakespeare's Globe to the origins of Shakespearean performance, a continuing theme of Mark Rylance's residency there as founding Artistic Director.

The production was staged in the hall as it might have been in 1602, with audiences in risers sitting along each wall and the actors performing along a *corridor* stage in the middle of the hall. The great timber screen at one end provided two doors that enable easy entrance and exit points, while the musicians were placed on the upper level of the screen above the actors. The hall was candlelit for the event. Audiences were provided with an Elizabethan *experience* as part of the pre-show in an attempt to recreate the atmosphere as well as the staging practices of a sixteenth century theatrical event. These performances enabled audiences to interact with the company in multiple ways within an intimate setting. Candlelit for the performances, the Hall, with its stained-glass windows and Elizabethan portraiture that decorated the walls, offered a direct connection to the original performance 400 years before.

After a short run in the Elizabethan hall, the company of actors moved into the reconstructed Globe Theatre and played there through the summer before embarking on a brief American tour in August 2003. It was revived again in 2012, transferred to the West End and eventually to Broadway, where it captured the imaginations of American audiences and critics alike. The theatrical style that the production exemplified, *Original Practices*, has had a lasting influence on the way that we imagine performance in Shakespeare's time. The term Original Practices was invented by Mark Rylance in 1997 to describe the theatrical experiment he felt should be the core mission of Sam Wanamaker's reconstructed theatre: to explore Shakespeare's language in relation to the theatre space; for actors to play with the audience; for audiences to experience first hand the visual and acoustic world of Shakespeare's great Globe Theatre. In addition to *playing* with an audience, as opposed to playing to or at them, what the actors wore and the kind of music that would accompany the performances became key features of Original Practices.

Jenny Tiramani refers to the actors' costumes in this context of Original Practices as *clothing*. One reason for doing so is again rooted in the basic principles that govern this performance style. After detailed research that involves examining surviving clothes or fragments of clothing from the sixteenth and seventeenth centuries and a sampling of Renaissance portraits, Tiramani and her team of crafts

people and makers design and construct clothing using period patterns (patterns of surviving garments and patterns drawn by tailors of the period), techniques and materials. Therefore, they make clothes not costumes. Another reason for referring to the garments the actors wear as *clothes* is because acting companies in Shakespeare's time would have spent large amounts of money on what they wore on stage, sometimes purchasing entire outfits from servants, who had inherited their Master's clothes but were unable to wear them, due to sumptuary legislation forbidding people within the lower social classes from wearing rich, expensive textiles. The actors in the sixteenth and seventeenth century theatre companies were often, therefore, wearing real clothes, not costumes.

The gown worn by Mark Rylance in his role as the Countess Olivia is an item of *clothing*. Designed by Tiramani, cut by Luca Costigliolo (a designer and maker, part of the Globe wardrobe department from 1999–2005) and made by Sarah Stammler and Debbie Watson. Olivia's outfit is a reproduction of a sixteenth-century Italian noblewoman's dress. It was made by hand, using sixteenth-century techniques and fabrics. The gown was worn over a white linen smock, a pair of boned silk bodies (corset) and layers of skirts, including a Spanish farthingale and a silk petticoat. Rylance's Olivia also wore stockings and garters underneath the skirts. Like any noblewoman from 1602, Olivia also wore accessories. The lace cuffs pinned to the sleeves are essential to the outfit's overall aesthetic and, conveniently help further in the illusion of femininity as Rylance was able to make smaller gestures with his hands, hiding their masculine attributes behind the elaborate lace. The large starched linen and lace neck ruff was not only crucial to the Elizabethan noblewoman's outfit but it helped to reflect light upon the face. In Rylance's case, the ruff was useful in disguising other distinctive male features, such as his Adam's apple. Other important accessories included: a rich, textural forepart tied around the petticoat that gave the illusion Olivia was wearing two expensive gowns; a lace hat, black veil, a coronet, and a jewelled head-tire—all of these items were worn at different points in the play when the language or setting required. All the outfits in this production were made according to the same historic guidelines, including the outfit that Viola wears when she is disguised as the Duke Orsino's boy, Cesario. The most striking element of Cesario's look is, perhaps, the beautifully-crafted silk thread wig(s) worn by Samuel Barnett. Drawing upon contemporary portraits, the designers in Tiramani's team created a look for Sebastian and Cesario that closely resembled the fashions for young Gentlemen in ca. 1600. This experiment in historical dress has taught us not only a great deal about the complex beauty of the clothes worn by Elizabethans, but also about how clothing directed bodily movement on the Shakespearean stage.

The production also explored the use of original makeup in order to create the full effect of Renaissance femininity. Because in the sixteenth and seventeenth centuries, the materials found

in cosmetic paints were largely poisonous, Tiramani and her team had to compromise. For the most part, they stuck to the principle of using only materials that were available in Shakespeare's time. The white base consisted of a mixture of plain chalk with pure pigment, crushed together with a little rose or almond oil. To create the darkened eyebrows, they dipped a brush into water and then into a pot of black lamp soot. Moroccan clay pots were used for the red in the lips and pink coloured chalk to create the blush in the cheeks. The idea was to create a simulacrum of the Renaissance beauty ideal which consisted of pale skin, pinkish/rose-coloured cheeks, dark eyes and small ruby lips. While in Shakespeare's time, there were very mixed views about makeup, some seeing it as sinful, hypocritical and disgusting ("slibber sauces", as it was colourfully described by puritan Philip Stubbes), the acting companies of the time made great use of cosmetics to paint the faces of boys to look like women and, as evident in *Twelfth Night*, to create the illusion of identical twins.

The other distinctive feature of Original Practices productions is the historical approach developed to create music for performances. Claire van Kampen decided it was important to "look at the practice of Renaissance music, and, working with early music practitioners... using only reconstructed period instruments without using amplification or electronic aids". Crucial to van Kampen's method, then, was the return to original "sources and references" as she puts it, which means searching for evidence of songs and music that might have been available to musicians and actors in the sixteenth and seventeenth centuries. Like Tiramani, van Kampen also draws on evidence from the particular year a play is set or was staged because musical trends and fashions had a tendency to change rapidly, as they do now. *Twelfth Night*, in particular, is a very musical play and there are several surviving period tunes that proved to be appropriate for the songs in the play text itself, such as "Ah Robin", sung by Feste as "Hey Robin", a song that can be found in the Henry VIII Manuscript of c. 1510–20 attributed to William Cornish. Because the evidence for instrumentation can be rather fragmented, van Kampen will select music from a range of sources to create her compositions and to shape the cues for the instrumental music in the productions. The language, verse and the story are organically tied to the methods and material practices of these productions, staged to showcase the extraordinary capacities of the reconstructed Globe itself.

This valuable experiment has not given us a new understanding of the look, feel and sound of Shakespearean performance in its original moment, but it has demonstrated to us, as audiences, our own desire to glimpse into the past and take one step closer to the magic of Shakespeare.

Essay from *Shakespeare in Ten Acts*, published by the British Library in 2016.

⑤ BELASCO THEATRE

111 West 44th Street
A Shubert Organization Theatre

Philip J. Smith, *Chairman* **Robert E. Wankel,** *President*

SONIA FRIEDMAN PRODUCTIONS SCOTT LANDIS ROGER BERLIND

GLASS HALF FULL PRODUCTIONS/JUST FOR LAUGHS THEATRICALS 1001 NIGHTS PRODUCTIONS

TULCHIN BARTNER PRODUCTIONS JANE BERGÈRE PAULA MARIE BLACK RUPERT GAVIN

STEPHANIE P. McCLELLAND SHAKESPEARE'S GLOBE CENTRE USA

MAX COOPER TANYA LINK PRODUCTIONS and SHAKESPEARE ROAD

present

SHAKESPEARE'S GLOBE
PRODUCTIONS OF

Mr. William Shakespeares

TWELFE NIGHT,
OR WHAT YOU WILL.

THE TRAGEDIE OF

KING RICHARD
THE THIRD

MARK RYLANCE

and
(in alphabetical order)

SAMUEL BARNETT LIAM BRENNAN PAUL CHAHIDI

JOHN PAUL CONNOLLY PETER HAMILTON DYER KURT EGYIAWAN

MATT HARRINGTON COLIN HURLEY TERRY McGINITY

JETHRO SKINNER JOSEPH TIMMS ANGUS WRIGHT

MATTHEW SCHECHTER HAYDEN SIGNORETTI

DOMINIC BREWER DYLAN CLARK MARSHALL TONY WARD

with STEPHEN FRY as MALVOLIO

Musicians

SAMUEL BUDISH ELIZABETH HARDY ARNGEIR HAUKSSON

PRISCILLA HERREID GREG INGLES KATHRYN MONTOYA ERIK SCHMALZ

Lighting Design	Choreography	Production Stage Manager
STAN PRESSNER	SIAN WILLIAMS	ARTHUR GAFFIN

UK Casting	US Casting
CHARLOTTE BEVAN, CDG	JIM CARNAHAN, CSA

US General Management	UK General Management	US Technical Supervision
BESPOKE THEATRICALS	DIANE BENJAMIN and FIONA STEWART for SONIA FRIEDMAN PRODUCTIONS	HUDSON THEATRICAL ASSOCIATES

Press Representatives	Advertising & Marketing
BONEAU/BRYAN-BROWN	SPOTCO

Designer	Music
JENNY TIRAMANI	CLAIRE van KAMPEN

Director
TIM CARROLL

Acknowledgements

Mum, Dad, Nancy, Simon, Tabby, Arthur, Elliot, Sam, Sid, Heather, Stella, James.
Actors' Equity Association, Phoebe Adler, Teresa Armitage, Samuel Barnett, Belasco Theatre, Diane Benjamin, Bespoke Theatricals, Charlotte Bevan, Boneau/Bryan-Brown, Liam Brennan, Dominic Brewer, Samuel Budish, Jim Carnahan, Tim Carroll, CDG, Paul Chahidi, Matthew Chrislip, Brian Clarke, John Paul Connolly, CSA, Tina Deane, John Eastman, Lee Eastman, Kurt Egyiawan, Charlotte Ellis, Sonia Friedman, Stephen Fry, Arthur Gaffin, Giulia Garbin, Wanda Gregory, Grace Guppy, Joe Hage, Peter Hamilton Dyer, Elizabeth Hardy, Matt Harrington, Arngeir Hauksson, Priscilla Herreid, Chris Howgate, Hudson Theatrical Associates, Colin Hurley, IATSE, Greg Ingles, Amy Jacobs, Local 1, Local 764, Local 798, Local 802, Local 829, Steven Loehle, Steve Macleod, Dylan Clark Marshall, Terry McGinity, Metro Imaging, Kathryn Montoya, Sean Mulcahy, Steve O'Connell, Bryan Paterson, Thomas Persson, Stan Pressner, Meryl Robertson, Annabel Robinson, Mark Rylance, Danielle Saks, Matthew Schechter, Erik Schmalz, Daniel Scott, Shakespeare's Globe, Hayden Signoretti, Jethro Skinner, Philip J. Smith, Spotco, Stage Directors and Choreographers, Fiona Stewart, Joseph Timms, Jenny Tiramani, Simon Turner, United Scenic Artists, Claire van Kampen, Robert E. Wankel, Tony Ward, Glenn Wassall, Sian Williams, Ben Warren, Angus Wright, Kasia Zdanowska.

Twelfth Night by Shakespeare was originally produced on Broadway by:
Jane Bergère, Roger Berlind, Paula Marie Black, Max Cooper, Sonia Friedman Productions, Rupert Gavin, Glass Half Full Productions/Just For Laughs Theatricals, Scott Landis, Stephanie P. McClelland, Shakespeare's Globe Centre USA, Shakespeare Road, Tanya Link Productions, Tulchin Bartner Productions, 1001 Nights Productions.

Please contact **sales@marymccartney.com** for Ltd Edition Print enquiries.

Published by HENI Publishing, London
© 2016 Mary McCartney
© 2016 HENI Publishing
ISBN 978-0-9933161-1-1

Publishing Manager: Phoebe Adler

A catalogue record for this book is available from The British Library.

For images and video of the original production visit:
soniafriedman.com/productions/twelfth-night-richard-iii-broadway/cast-creative-team

Art Direction: Thomas Persson
Design: Giulia Garbin

Print: Park Communications
Case bound: Diamond Print Finishers
Cover paper: KeayKolour Snow white and Claro Gloss
Text paper: Magno Volume
End papers: Winter&Company Natural
Typeface: Sabon